IMAGES
of America

MONTEVALLO

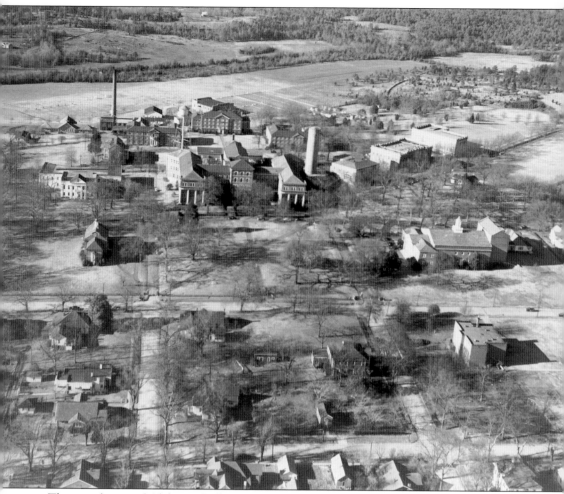

This aerial view of Alabama College was taken in the early 1940s. The photograph shows the growth of the campus around its three earliest structures: Reynolds Hall, painted white (center left), Main Hall (center), and the Tower (center right). Other notable buildings include the three later dormitories: Ramsay, Tutwiler, and Hanson. To the right of the Tower stand academic buildings: the Library (later Wills Hall), Bloch Hall, and Comer Hall. (Courtesy of Carmichael Library's University Archives and Special Collections.)

ON THE COVER: This 1960 photograph shows Montevallo students and the campus chief of police at the front gate at the intersection of Oak and North Boundary Streets. Saylor House is visible in the background. (Courtesy of Carmichael Library's University Archives and Special Collections.)

IMAGES
of America

MONTEVALLO

Clark Hultquist and Carey Heatherly

ARCADIA
PUBLISHING

Published by Arcadia Publishing
Charleston, South Carolina

Printed in the United States of America

Library of Congress Control Number: 2010937085

For all general information, please contact Arcadia Publishing:
Telephone 843-853-2070
Fax 843-853-0044
E-mail sales@arcadiapublishing.com
For customer service and orders:
Toll-Free 1-888-313-2665

Visit us on the Internet at www.arcadiapublishing.com

CONTENTS

ACKNOWLEDGMENTS

Any writing project is a collectivist enterprise. We are most grateful for the help and assistance of our University of Montevallo colleagues and students. While space precludes us from thanking them all, we express our gratitude to Mary Beth Armstrong, Rosemary Arneson, Racheal Banks, Robert W. Barone, Barbara Belisle, James S. Day, Wilson Fallin, Olivia Folmar, Amanda Fox, Stacia Love, Kathy Lowe, Michael Messina, Carolyn Miller-Kirby, Matthew Orton, Jamie Rawls, Jack Riley, Libbie Rodgers, Patsy Sears, Cynthia Shackelford, J. Corey Stewart, Ruth Smith Truss, Susan Vaughn, Joe Walsh, and Collin Williams.

Thanks also go to friends and members of the local Montevallo community, Jadie Allen Brown and Paul Brown, Becky Bolton Crisswell, Henry Emfinger and the Aldrich Coal Mine Museum, Shelby Harkins, Ken Jones, John C. Kirby, J. Ross McCain, Bruce and Jane McClanahan, Cheryl and Michael Patton, Melanie Poole, Bobby Joe Seales of the Shelby County Historical Society, Janet Seaman, Howard Stanger, Thomas G. Walker Jr., and Mary Lou Williams.

Unless otherwise noted, all images appear courtesy of the Carmichael Library's University Archives and Special Collections located at the University of Montevallo. Photographs from the University of Montevallo Public Relations Office and Photo Lab are courtesy of Matthew Orton.

We give special thanks to our editors at Arcadia Publishing, Katie Shayda and Brinkley Taliaferro, for guiding us through the production of this work.

From Carey Heatherly: For my girls, Mandy, Ava, and Celia.

From Clark Hultquist: I am grateful for the unwavering support of my family and friends. Thanks to you all.

INTRODUCTION

Montevallo—a "mountain in a valley." This bucolic, natural phrase aptly describes the beauty of this central Alabama town that resides at the tail end of the Appalachian Mountains. Long home to the Creek tribes, the first white settler, Jesse Wilson, staked his claim here in 1814. Soon afterward, others moved west from Georgia, calling the area "Wilson's Hill" in 1822, and then Montevallo in 1826. Agriculture was the focus of the area's economy as fertile soil and ample rainfall provided excellent conditions for supporting the budding community. This abundance attracted Virginia planter Edmund King, who bought land here in 1817 and soon became the largest stakeholder in the county. His mansion house, built in 1823, first known as Kingswood and now known as King House, still stands at the core of the university campus.

Higher education nearly came to the town in the 1820s as Alabama was choosing a locale for its new state university. Montevallo lost to the then–state capital Tuscaloosa by one vote. However, a by-product of that selection process produced the town's regular grid pattern that one can still see today.

The Alabama State Legislature incorporated the town of nearly 1,000 people in 1848. Soon after, prospectors discovered rich sources of coal near the town, and into the mid-20th century, mining remained an important source of wealth and employment in the area. With the mid-century arrival of the Alabama and Tennessee River Railway, Montevallo became a busy hub of activity as a stopping place between Birmingham, Selma, and, eventually, Montgomery.

The Civil War disrupted Montevallo's growth as the March 1865 attack known as "Wilson's Raid," led by Union general James H. Wilson, targeted mining, ammunition, and iron manufacturing in the area. Furthermore, the Louisville and Nashville Railroad (L&N) chose to bypass Montevallo on the line between Birmingham and Montgomery. These two setbacks were overcome by the role that education would play in the community.

Education proceeded by fits and starts in the town. The 1850s saw the establishment of academies or high schools that were short-lived but indicated the need for secondary education in the community. A byproduct of this era was the construction of the still-standing Reynolds Hall (1851) and Lyman Hall, now Saylor House (1858). Montevallo's prime location and political connections eventually saw the town win out in a state competition, which resulted in the establishment of the Alabama Girls' Industrial School in 1896. With this institution, the nature of the town changed significantly as the focus of the area began to shift, gradually, from mining and agriculture to education.

Focusing on the natural beauty of the area, the Olmsted Brothers firm of Brookline, Massachusetts, laid out the central campus, and its master plan still inspires current development projects (keeping the redbrick streets and buildings architecturally consistent). The school itself has seen several eras and name changes (Alabama Girls' Technical Institute, Alabama College, and The University of Montevallo) and now has a mission to be Alabama's only Public Liberal Arts University. It is a member of the nationwide Council of Public Liberal Arts Colleges. Today, the

university has over 3,000 current students and 21,000 alumni. Montevallo has the tradition of being a multi-generational campus where it is not uncommon to have students mention that their grandparents attended. In 1979, the US National Park Service designated the central part of campus as a National Historic District, and 28 sites and structures are on the National Register of Historic Places.

Montevallo is fortunate to have preserved some of its older buildings, which reflect varying architectural styles. Most of these significant and/or older structures of the town are on campus, including King House (1823), Reynolds Hall (1851), and Main Hall (1897). Notable town buildings include Perry Hall (1834), McKibbon House (1884), and the c. 1890s Peterson Home, the 1936 Works Progress Administration Viaduct (the Don H. Lovelady Bridge), the First United Methodist Church (1911), and the Montevallo Post Office (1937). The post office houses a mural, *Early Settlers of Shelby County*, painted by William S. McCall in 1939.

While education has become a strength of the community, the arrival in the 1990s and the 2000s of the American Village and the Alabama National Cemetery have provided a new influx of visitors to the area. Easy access to Interstate 65, proximity to the city of Birmingham, and the growth of Shelby County has caused the town to expand to over 5,000 residents. As a result, Montevallo has avoided the problems of many small Alabama towns since the 1960s: depopulation, boarded-up storefronts, and a reduction in civic life. Throughout this development, however, the area has retained its Southern charm and relaxed pace of life.

Retailing and services have been a mainstay of Main Street and beyond. From early enterprises like Kroells, Davies and Jeter, the Strand Theatre, the various businesses of Jadie Allen Brown, the Plaza Grill Café, and Klotzman's, to the more recent ventures of Seaman Timber, the House of Serendipity, or Eclipse Coffee and Books, Montevallo has been a self-sustaining community.

The area has produced memorable figures. Montevallo alumni include the stage and screen actress Polly Holliday, retired major league baseball star Rusty Greer, and Broadway actress Rebecca Luker. In 2010, Home Box Office broadcast the miniseries *The Pacific*. One of the three main characters portrayed in this drama was longtime University of Montevallo biology professor Eugene Sledge (1923–2001). Historians and scholars have considered Sledge's memoir, *With the Old Breed*, to be one of the finest works of 20th-century war literature. Montevallo native Walter Patrick McConaughy rose to become the US assistant secretary of state for Eastern affairs in the 1960s.

Through the pages of this book, the authors hope the readers gain an appreciation of the people, the buildings, and the landscape of this central Alabama town. While this work can by no means serve as a comprehensive photographic history of the town and college, the authors have tried to capture the broader themes of development and change, constancy and tradition, celebration and joy, and character and personality. Stroll the campus and see the buildings. Enjoy a performance at College Night. Take a walk through Orr Park. Ride a hack from the train depot to town. Enjoy this visit to the past.

One

EARLY MONTEVALLO

Montevallo, from its founding to the 1940s, witnessed a transformation that took the tiny village through several stages. Early on, because of the richness of the land, Montevallo thrived as an agricultural center. With the building of railways and the nearby discovery of coal in the 1870s, the economy began to shift to mining. By 1900, education and services began to challenge agriculture and mining as the dominant employers. These images reflect some of those changes. Montevallo, fortunately, preserved several structures from this era, and many of these photographs reflect their enduring architectural legacy. Victorian-style houses dominated the town up to the early 1900s, as did Victorian-style dress. The automobile came to Montevallo at this time and transformed the town as the dirt streets slowly gave way to paved roads. While the Great Depression affected Montevallo, the community could rely on education, agriculture, and Works Progress Administration projects to ease the pain of economic dislocation.

The reader will profit from a second and third look at these photographs. While many of these images contain iconic locations or individuals, closer scrutiny provides additional insights: see the gas lamp on the street corner, the planks used to cover the mud on the unpaved roads, the clock in the storefront window frozen at 2:55, the family posing in the rail cars, the advertisements on the buildings, and finally, the quality and style of the clothing.

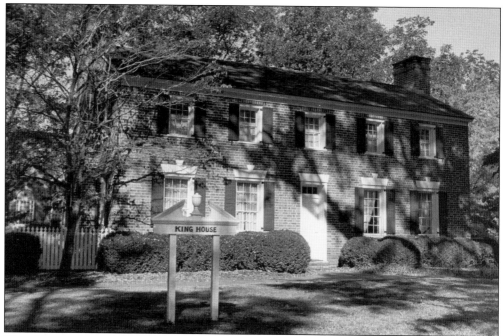

The oldest building in Montevallo is King House (1823). Built by the planter Edmund King, it was the first home in the area to have glass windows. The home, bought by the college in 1908, has served several roles: an infirmary, offices for psychology and financial aid, and as a practice house for home economics. The structure underwent extensive restoration in the 1970s and now serves as a campus guest home and reception place.

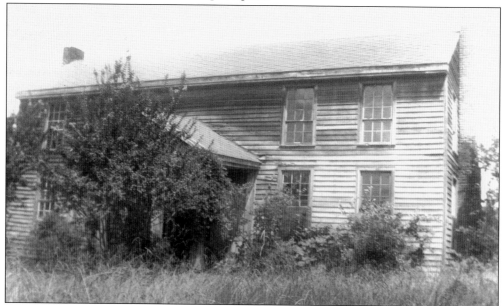

Perry Hall is one of the oldest houses in Montevallo to still stand. Built in 1834 by Jacob Perry, the home was the heart of a small plantation that operated cotton fields, orchards, vineyards, and vegetable gardens, becoming nearly self-sufficient before the Civil War. The home survived the war, though it eventually fell into disrepair before being restored and modernized.

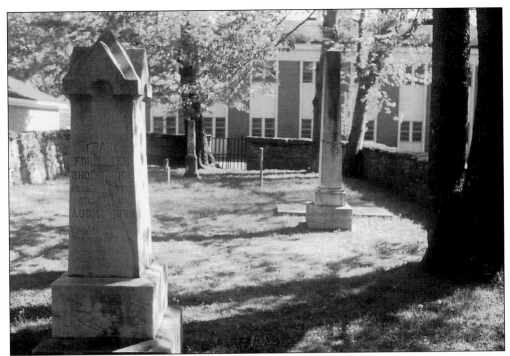

King Cemetery holds the gravesites of 12 family members, the earliest being that of Nancy King in 1842. A short blue limestone wall surrounds the cemetery with academic buildings visible nearby. The last of the King family members to be buried here was Elizabeth King Shortridge in 1902. (Courtesy of Matthew Orton, University of Montevallo.)

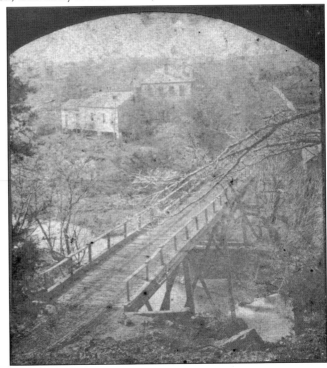

This is one of the oldest-known photographs of Montevallo, taken sometime in the 1850s. It depicts the bridge over Shoal Creek that served to connect the town to the railway station. The two visible houses belonged to the Lum Wells family (left) and the Widow Adams (right).

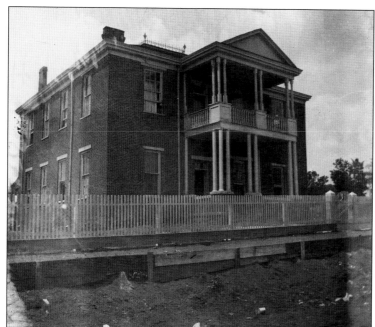

Saylor House, built in the 1850s, was originally known as Lyman Hall. The structure first served as rooms for men for the Montevallo Male and Female Institute. The college purchased the building in 1952 and remodeled it for use as faculty apartments.

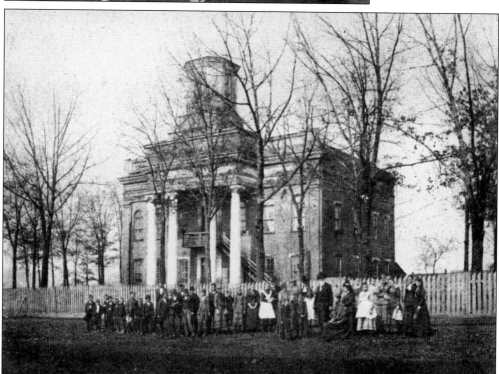

The Montevallo Male Institute was built in 1851 as a local school for young men. In 1858, the Cumberland Presbyterian Church operated the site as the Montevallo Male and Female Collegiate Institute. This picture predates the Civil War. The war caused shortages, forcing the school to close. Gen. C.M. Shelley laid out the building and used bricks baked on the site. Known as Reynolds Hall today, the building is painted white to protect the bricks.

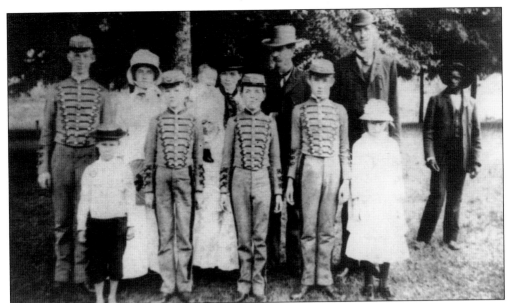

This 1882 photograph depicts Captain Reynolds and his family. From left to right are (first row) Harry, Fred, Sam Allen, Herbert, and Belle; (second row) Edward, Bessie, Maude, Mary Boyd, Captain Reynolds, William Boyd, and Martin Goodman.

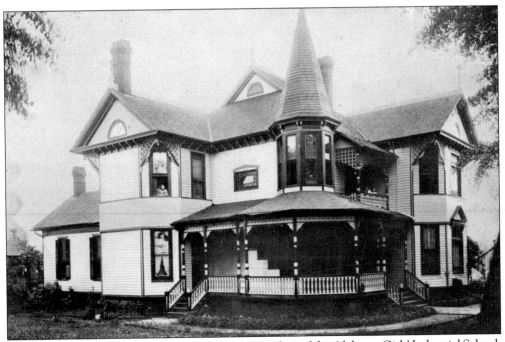

This was the home of Henry Clay Reynolds, first president of the Alabama Girls' Industrial School. The rooftops, steeply pitched to prevent an accumulation of snow (unlikely in Alabama) were signs of the German architect Pulls's influence. Located at the intersection of Main and Middle Streets, this home was demolished in the 1960s for a shopping plaza.

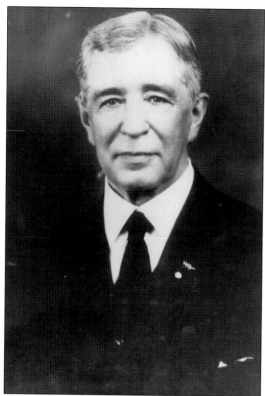

William F. Aldrich (1853–1925) was born in Palmyra, New York, and settled in Alabama in 1874 along with his brother, Truman H. Aldrich, where they built the self-named community of Aldrich, a satellite town to Montevallo by 1883. William F. Aldrich became principal stockholder of a mining concern eventually to be named the Montevallo Coal Company. He was elected to the U.S. Congress on three occasions. He was buried in Washington, D.C. (Courtesy of Aldrich Coal Mine Museum.)

Rajah Lodge, surrounded by sculptured grounds and flowerbeds, was the residence of William F. and Josephine C. Aldrich. The rambling Victorian house had eccentric architectural features such as a conical dome tower and extended gables. The Aldrich family moved to the city of Birmingham in 1912, and Rajah Lodge fell into a state of disrepair. It was partially demolished in 1923 and finally razed in 1947. (Courtesy of Aldrich Coal Mine Museum.)

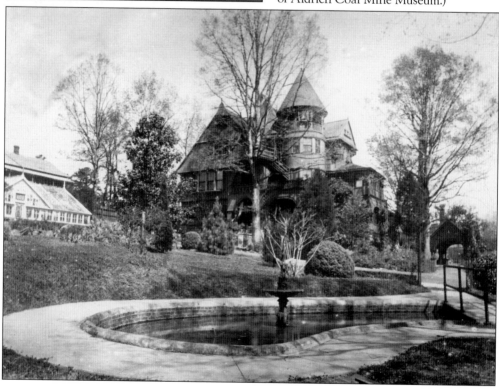

The two-story Farrington Hall was built with cement, steel, and brick in 1908. Originally the office of Congressman William F. Aldrich, it was later used until 1942 by the Montevallo Coal Company. The office included features such as frescoes by Giuseppe Moretti, best known for his *Vulcan* statue in Birmingham, wrought-iron lanterns, a mosaic floor, and a large recreation room. The building is named after the congressman's son, Farrington. (Courtesy of Aldrich Coal Mine Museum.)

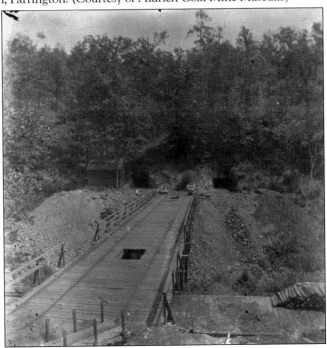

The greater Montevallo area in the 1890s had several coalmines to the northwest, especially in nearby Aldrich. This family photograph shows a two-tracked bridge, each track entering a different mine shaft. In front of each mine entrance, one can discern a mother and two children (left) and three children (right) posing atop rail cars.

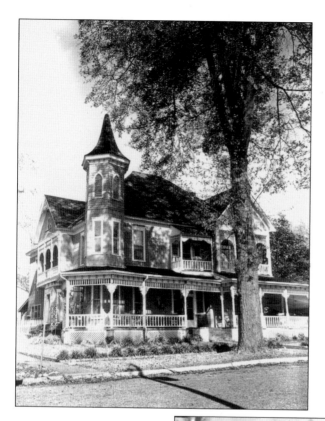

The Victorian-style McKibbon House, located at 611 East Boundary Street, was built in 1884 and is one of the finest examples of late 19th-century architecture in the town. The home has been restored into a bed-and-breakfast inn.

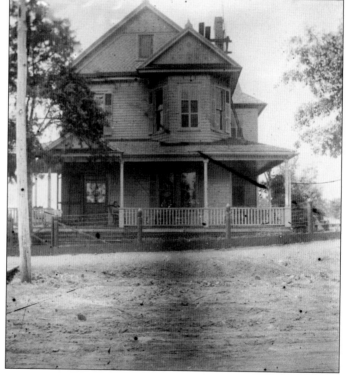

This was the private residence of Francis Marion Peterson, second president of the Alabama Girls' Industrial School, built in a Victorian style. The structure, still standing, is noted for its asymmetrical shape and architectural ornamentation. Few of these houses now remain in the city.

Rail service first came to Montevallo in 1853 when the Alabama and Tennessee River Railway completed a 55-mile link to Selma. By 1896, six passenger trains a day made stops in Montevallo, and a number of freight trains made deliveries to the bustling city. Rail transportation was fraught with peril, and accidents were not uncommon. This photograph shows a Seaboard Air Line Railroad train derailed not far outside of town near modern-day Highway 25.

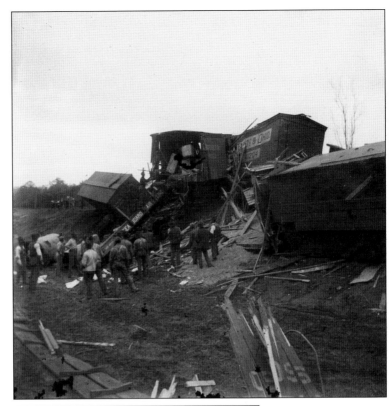

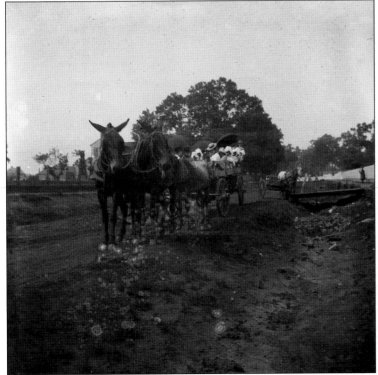

This late 1890s photograph shows passengers in a hack. These hacks, pulled by a team of mules, served as a type of taxi service for people and luggage from the railroad depot to the school. The George Kroell livery provided most of the hack transportation in town.

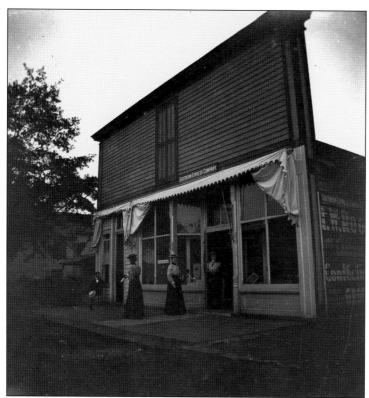

Frank W. Rogan, brother-in-law to Henry Clay Reynolds, president of the Alabama Girls' Industrial School, owned a number of businesses around 1900 in Montevallo including the Southern Express Company, which offered fine candies, confections, and fancy groceries. Rogan served as a mortician, sold caskets, and provided an ambulance service to the town.

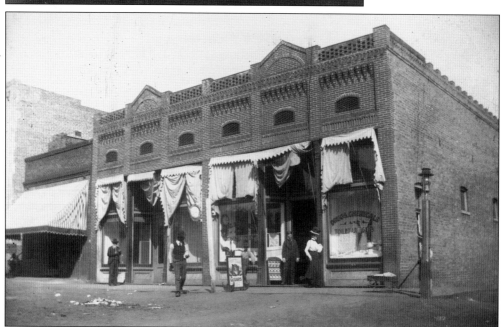

Montevallo's early-1900s Main Street hosted a number of retail establishments. The unpaved streets, according to contemporary residents, turned into muddy rivers during heavy rains. Located at the intersection of Main and Middle Streets, this store sold music, art supplies, drugs, and toilet articles. The structure currently houses Czeskleba TV Service.

Dr. J.W. Acker (1837–1923) was twice wounded during his service in the Confederate army. As a physician, he performed battlefield operations, many of them amputations, with a handsaw and no anesthetics. He served the Montevallo community for many years as an obstetrician, and after his retirement, remained a vital figure always ready to regale an audience with stories of his life.

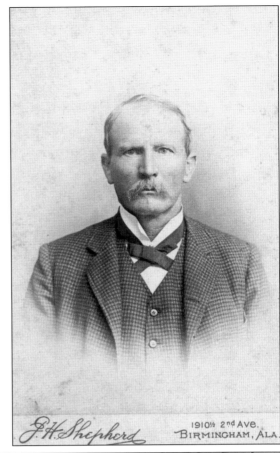

J.H. Shephord 1910½ 2nd Ave.
BIRMINGHAM, ALA.

This 1896–1897 Alabama Girls' Industrial School catalog photograph depicts a "View from the foot of Main Street." In the middle ground is Shoal Creek, a favorite spot for recreation that also served as a water source for the town and school. These picturesque photographs were included in the catalog as an enticement for parents eager to send their daughters to a safe, bucolic setting.

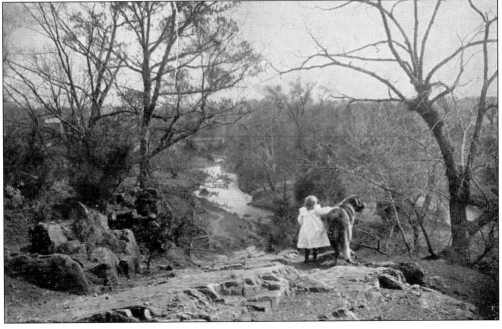

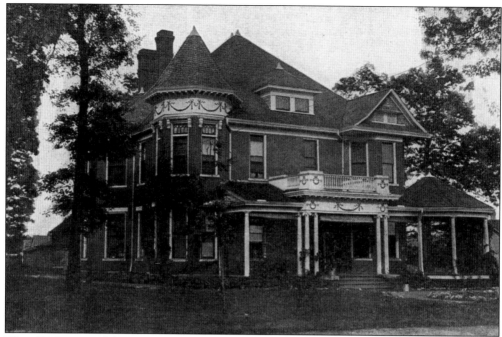

This 1906–1907 Alabama Girls' Industrial School catalog photograph depicts the president's home. Thomas Waverly Palmer and family occupied the home from 1907 to 1921, when fire destroyed the residence. The house stood near where the *Becoming* sculpture currently resides. The loss of this structure required the college to build a new home for the president, completed in 1926, now called Flowerhill.

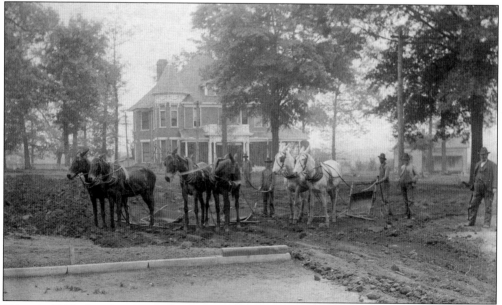

Taken in 1908, this photograph shows the initial construction of Stallworth Dormitory, the east wing of Main Hall. The school's early success led to increasing enrollment and required additional living quarters for the students. William Ernest Spink of Birmingham was the architect. The president's home stands in the background.

Secondary education in the town of Montevallo was housed in several different sites (a brick-house training school in 1915, a school where Palmer Hall now sits, and briefly, Reynolds Hall in the 1920s) before Montevallo High School's construction in 1929. This building had nine classrooms, a library, a study hall, and a science laboratory. Today, the school houses over 350 students. In 1948, the town added a vocational building on the school grounds.

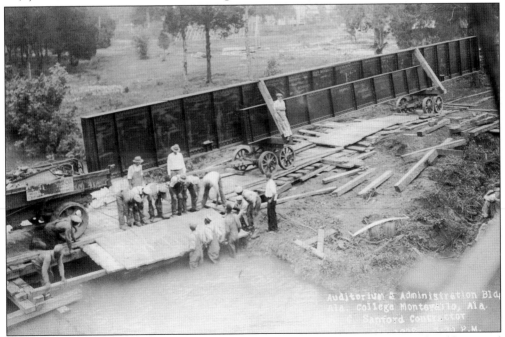

During the construction of Thomas Waverly Palmer Hall in 1929, the contractor ordered large steel beams that had to be shipped by rail from Bessemer, Alabama. Once the beams were delivered, workmen built a temporary bridge in order to transport them across Shoal Creek, nearly a mile from campus.

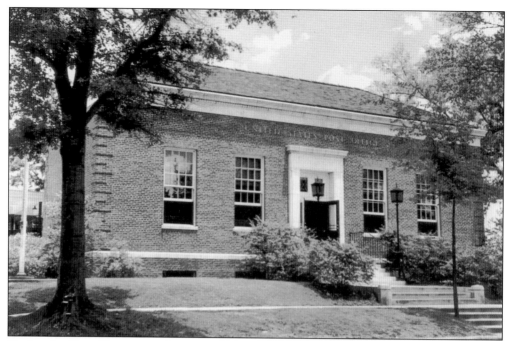

During the Great Depression, the town of Montevallo received a grant from the Works Progress Administration in 1936 to build a new post office. Completed in 1937, the $52,000 building had a redbrick exterior with white Georgian marble trim in the interior. The interior also features a large mural painted by William S. McCall entitled *The Early Settlers of Shelby County* (below). (Both courtesy of Aldrich Coal Mine Museum.)

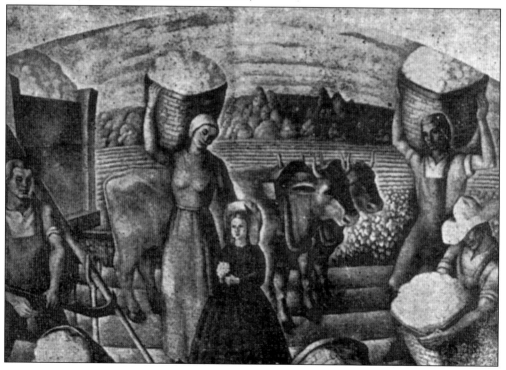

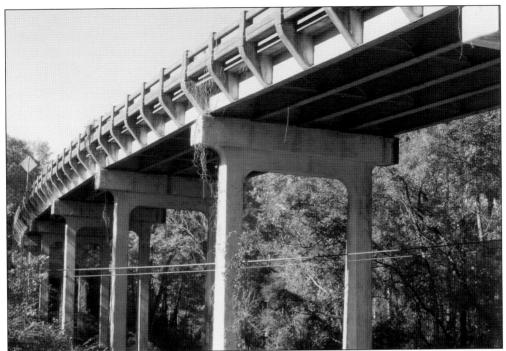

A product of the Works Progress Administration, the Montevallo Viaduct (Don H. Lovelady Bridge) was a proud addition to the town in 1936. The 620-foot long bridge allowed a safer and more convenient connection by highway to both Birmingham and Montgomery. Its unique feature was that it spanned three separate obstacles: a highway, a railway, and Shoal Creek. (Courtesy of Clark Hultquist.)

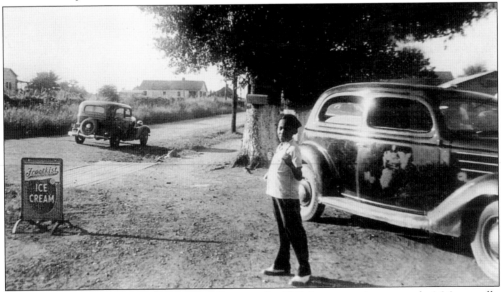

Homer Givhan is seen standing on Selma Street in the Shiloh community near today's Montevallo Middle School. In 1939, a tornado swept through Shiloh, damaging several homes. This photograph was taken a few years later in front of a small store that was advertising "Frostkist Ice Cream." (Courtesy of Barbara Belisle.)

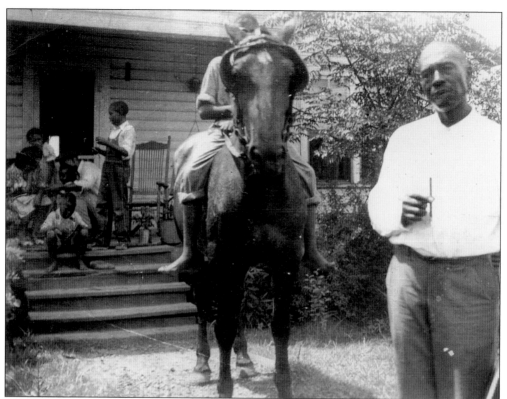

This c. 1940 image shows a still-standing house in the Shiloh community near today's Montevallo Middle School. From left to right are Tennie Lou Cottingham, unidentified, Louie Cottingham, Barbara Belisle, Will Nelson, Elbert Cottingham, Charles Cottingham, and George Washington Cottingham. George Washington Cottingham was grandson to a slave featured in Douglas Blackmon's Pulitzer prize–winning book, *Slavery By Another Name*. Barbara Belisle was the first African American teacher at Montevallo High School. (Courtesy of Barbara Belisle.)

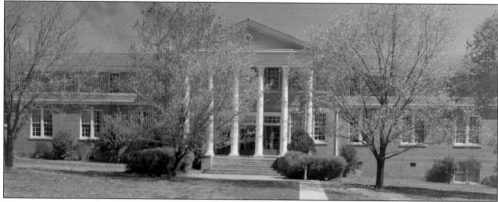

This photograph shows the main structure at Montevallo High School. A 1929 *Birmingham News* article noted that the much-needed building would boast "12 classrooms, laboratory rooms, a library, study hall, and ample office space for the high school training faculty and staff." A $15,000 appropriation by the Alabama State Board of Education financed the building's construction, and a further $7,000 would fund "teachers and pupils' desks, laboratory supplies, maps, and other teaching supplies."

Two

BUSINESSES AND RETAIL ESTABLISHMENTS

The "downtown" of Montevallo has characteristics that most small cities possess: banks, pharmacies, dry goods, clothing stores, public utilities, services, restaurants, and entertainment (à la a movie theater). While the strip of Main Street is less than a half-mile long, several dozen merchants plied their trades along the road—some for a few years, some for nearly a century. Main Street was not only a gathering place for the citizens of Montevallo, but it also attracted those from the smaller satellite villages nearby such as Wilton, Aldrich, Moore's Crossroads, and Pea Ridge. These photographs capture the nature and flavor of the town during the 20th century and also reflect the larger socioeconomic changes transforming the nation.

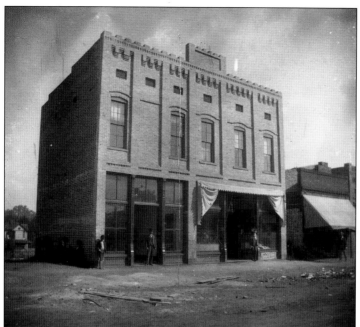

Davies and Jeter was a Montevallo retailer specializing in clothes, linens, and shoes. A 1902 advertisement stated: "Our stock of dress goods is the most complete ever shown in Montevallo . . . why have your clothes made by scab measurers, when we can guarantee a perfect fit at a savings from $5 to $10 on every suit." A tagline noted, "In fact all fashionable goods at unfashionable prices."

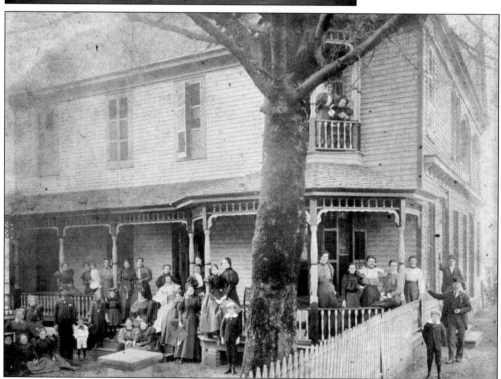

In the 1880s, Henry and Sam Latham moved to Montevallo, where the brothers operated a general merchandise store. Henry Latham made an addition to his house, and this served as the Magnolia Hotel, located at Shelby and Main Streets. In the late 1890s, the hotel housed young women from the Alabama Girl's Industrial Institute as dormitory space was still in short supply pending the completion of Main Hall.

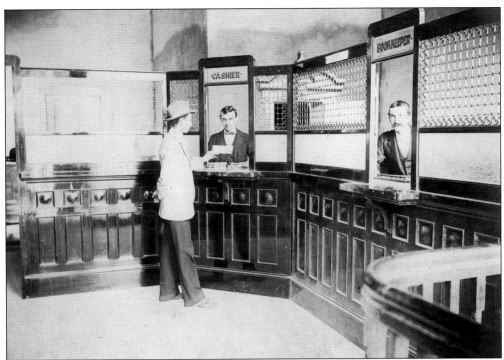

This c. 1905 photograph shows the lobby of Merchants & Planters Bank. A 1902 advertisement for the enterprise at its birth stated: "We want our friends to give us their influence and help us to build up one of the best and safest banks in Alabama." Changes in U.S. federal law making bank robbery a more serious offense would eventually see the cages removed, giving the lobby a friendlier appearance.

At right is an advertisement for the Montevallo Coal Company located in nearby Aldrich. The mine supplied coal to the Confederate government. After the war, the mine was purchased by civil engineer Truman Aldrich, who founded the company and the camp named for him. The firm used convict labor, and the town housed a small prison and cemetery. (Courtesy of Aldrich Coal Mine Museum.)

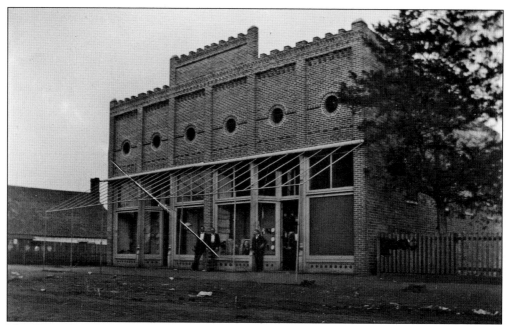

The George Kroell store was long one of the major retail establishments in the town of Montevallo. Connected to the store was a livery stable, which proved to be quite profitable before the automobile era. A 1914 yearbook advertisement read, "Kroell's is the place for everything, eatables and wearables. Buster Brown Hose a Specialty. Everything in the School Girl line. Come! Look! Buy!" The store no longer stands.

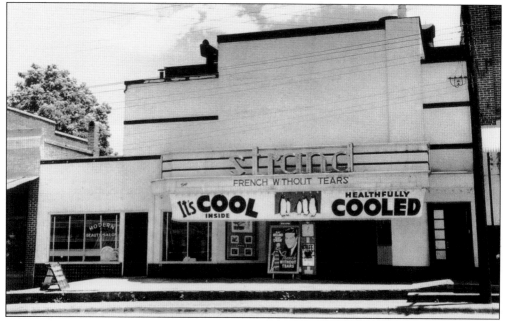

The Strand Theatre at 620 Main Street, seen in this 1940 image, was a longtime Montevallo establishment. Besides movies, the theater also hosted live shows and performances, selling popcorn at 10¢ a bag. To the right of the theater marquee is the segregated entrance that led to balcony seating. Today, the building houses The Stranded Art Cooperative.

This c. 1940 image shows the exterior of the Merchants and Planters Bank. Many of the early leaders of the Alabama Girls' Industrial School were prominent bankers and businessmen, some holding roles as school administrators and bank board members. The building still stands and houses the office of State Farm insurance agent Bob Butterworth.

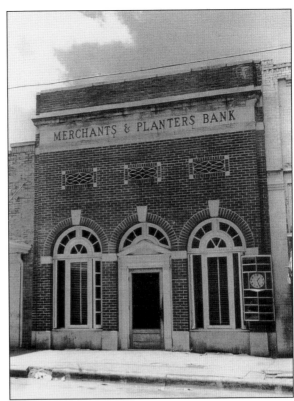

Taken from the intersection of Middle and Main Streets, this 1940 image shows the other end of downtown Montevallo, with Wilson Drug Company, Hick's Ben Franklin Stores, and the Montevallo Drug Company. Not long after, in 1949, the Montevallo Chamber of Commerce was organized. Charter members included Milton Jeter (president), R.E. Whaley, Don and Bill Lovelady, Sam Klotzman, Stanley Mahan, Ellis Hoffman, Fred Frost, and Mac Wyatt.

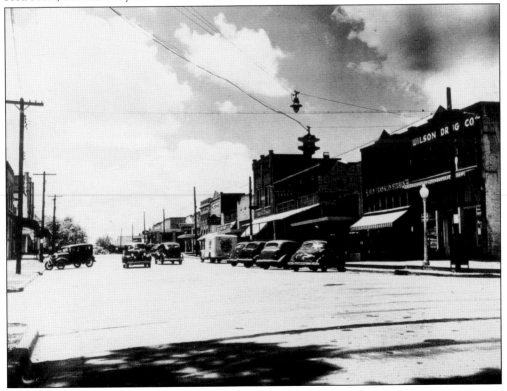

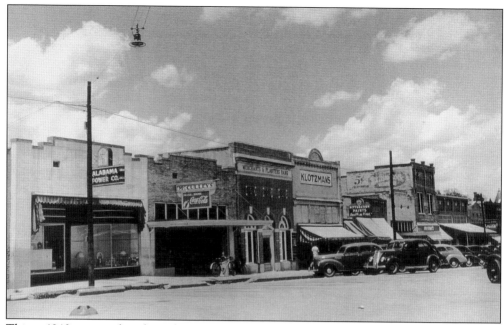

This c. 1940 image taken from the intersection of Shelby and Main Streets shows the heart of downtown Montevallo, with the Alabama Power Company, McCulley's Grocery, Merchants and Planters Bank, Klotzman's (clothing store), and Holcombe's (restaurant).

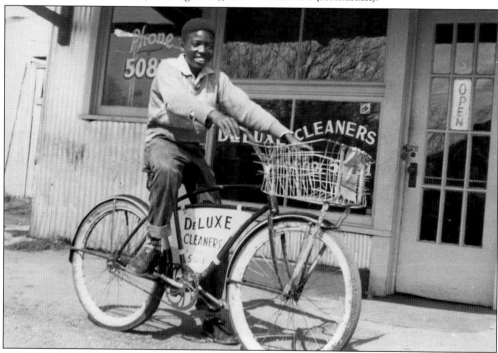

Deluxe Cleaners, operated by Clarence Chism, was located on Main Street near the city hall. The store operated a drop-off and pick-up service, sometimes using young men on bicycles. By the 1960s, the cleaners stationed three Alabama College students as dormitory representatives who would pick up and deliver clothes. (Courtesy of Aldrich Coal Mine Museum.)

Located on Main Street, Klotzman's was a clothing and dry-goods store that serviced both the community and the college. A 1941 store holiday advertisement stated, "Say, you folks haven't anything to worry about! We have all sorts of presents and INEXPENSIVE too! For REAL MEN and for REAL WOMEN."

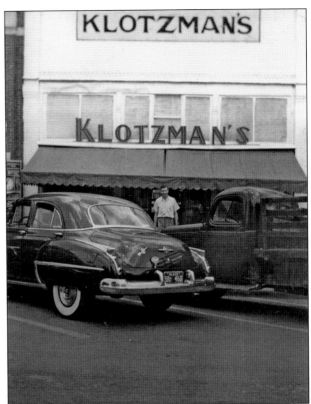

Founded by William L. Brown and his two sons in 1935, the Alabama Coach Company operated for over 50 years. Before widespread automobile ownership, the firm provided essential transportation to locales such as Calera, Sylacauga, Tuscaloosa, and Centerville. Headquartered at the intersection of Main and North Boundary Streets, the company operated over 20 buses at its peak.

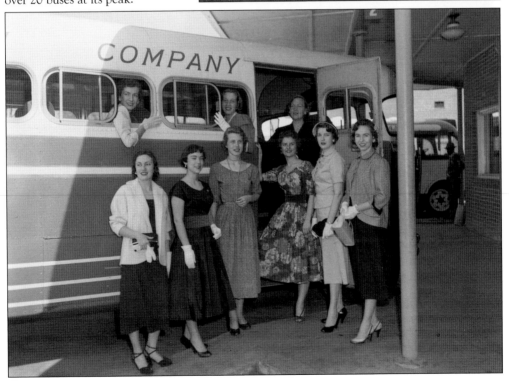

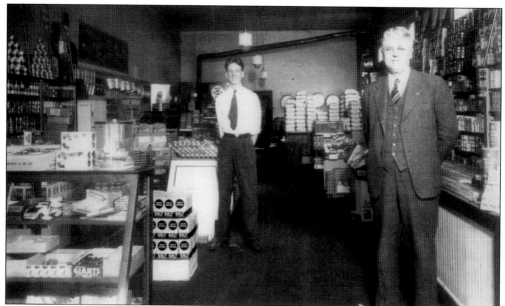

This c. 1950 photograph shows Jadie Allen Brown Jr. (left, 1920–) and his father, Jadie Allen Brown Sr. (1886–1953), in their store, Brown Trading Company, located near the intersection of Shelby Street and Spring Creek Road. The Brown family had come to Montevallo in the 1880s and established a sawmill as their first business. Brown Sr. served twice as city mayor, and Brown Jr. served 32 years on the city council. (Courtesy of Paul Brown.)

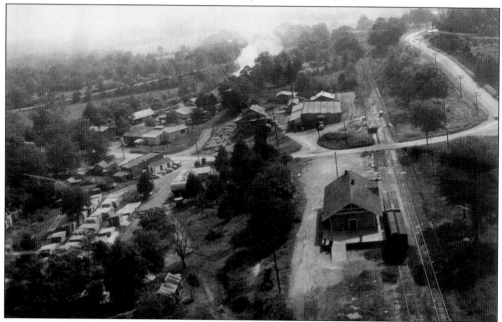

This c. 1950 aerial photograph shows the business complex of the J.A. Brown family. On the left are the Brown Trading Company, The Brown Gin Company, The Brown Lumberyard, and Acme Oil. On the top right is the Brown Moulding Company, with the Montevallo Train Depot below. By the 1960s, Brown Moulding became one of the largest manufacturers and distributors of wood moulding in the country servicing over 15 states. (Courtesy of Paul Brown.)

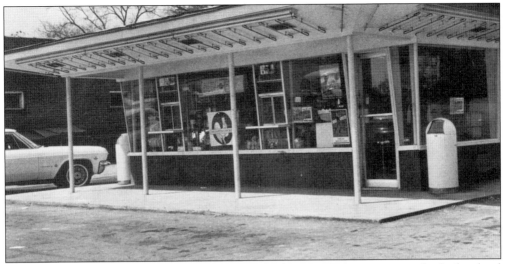

Located at 925 Main Street and owned by Mr. Rhodes, Dari-Delite was a popular high school and college gathering place for ice cream, snacks, and beverages. A 1966 advertisement notes the restaurant's 10¢ Cokes, 20¢ corn dogs, 25¢ hamburgers, 30¢ milk shakes, and outdoor eating area. The store's cartoon mascots were "Dee" and "Dee Dee." In the 2000s, the building housed a Chinese restaurant that has since closed.

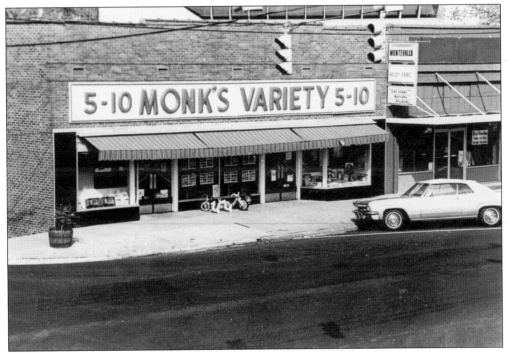

The town of Montevallo long hosted several "five and dime" retailers until large big-box chain stores moved to the suburbs. Monk's Variety 5 & 10, which had replaced Hick's Ben Franklin store, sat at the corner of Main and Middle Streets. This business sold the usual trinkets and daily use products.

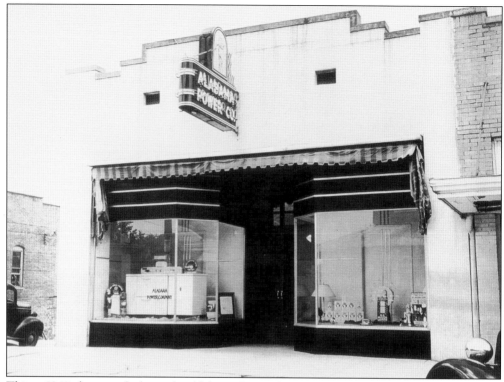

This c. 1940 photograph shows the Alabama Power Company building located on the corner of Main and Shelby Streets. Local residents could pay their bills and buy household appliances at the store. A 1935 company advertisement placed in a local newspaper noted that "it will cost you less than $10 to have a Hotpoint installed in your kitchen. Balance payable in 24 months."

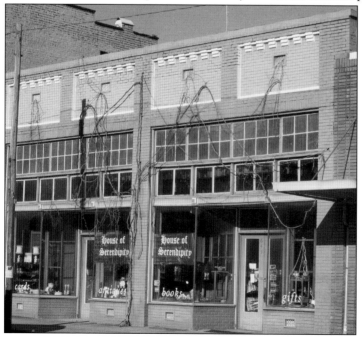

The House of Serendipity was founded by Bruce and Jane McClanahan in 1973 as a mail-order company. The business moved into the Whaley Shopping Center in 1975 and to its current location at 645 Main Street in 1978. It operates today as a bookstore and a major tableware matching service. (Courtesy of Clark Hultquist.)

Three

CHURCHES AND ASSEMBLIES

The greater Montevallo area is home to more than a dozen sites of worship. These places were not only for religious observances but they also formed another social network for the town, providing contacts, friendship, and community. Furthermore, these institutions helped provide a safety net for the less-fortunate of the community by performing food and clothing drives, offering short-term housing, counseling, and support during times of need, and even educational programs. Some of these congregations have a long history, dating well back into the 1800s. Whether large or small, old or new, these organizations provided an important sense of identity and place in Montevallo through the years.

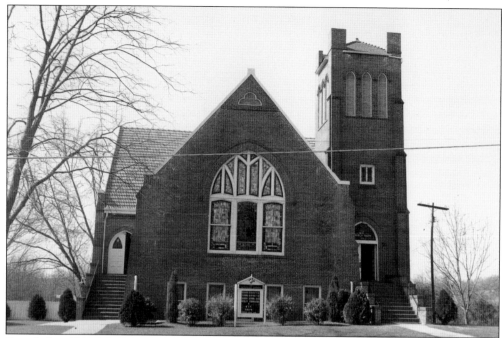

Founded in 1818, The First United Methodist Church is the oldest organized congregation in Montevallo. The current building, constructed in 1911, sitting on the corner of Middle and Oak Streets, represents the assembly's fifth location. The sanctuary features an Ernest Skinner organ with 1,037 pipes.

Montevallo First Baptist Church was organized in 1855. The congregation built its first building on land donated by Edmund King, the site of which is now occupied by Main Dormitory. The current structure, built in 1910, sits at the intersection of Main and Middle Streets.

Formally organized in 1860, St Andrews Episcopal Church built its first structure on Valley Street. Storms destroyed the church in both 1873 and 1939, after which the congregation met on campus in Calkins Hall for the next 14 years. In 1953, the congregation constructed a new, modified English-style building, now located at Plowman and Oak Streets.

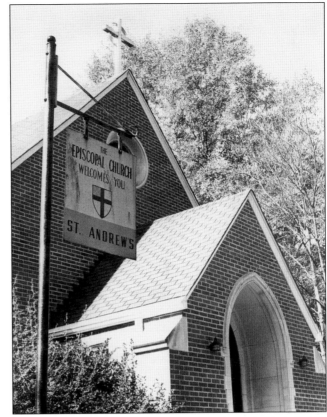

After the Civil War, Montevallo's Presbyterian congregation fell into disarray, and it was not until 1897 that it reorganized into the Montevallo Presbyterian Church. Built in 1902, the church now sits at the corner of Shelby and Alabama Streets. Henry Clay Reynolds deeded land to several churches in town, one of which was Montevallo Presbyterian.

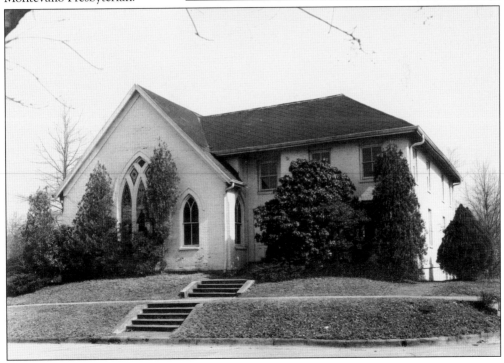

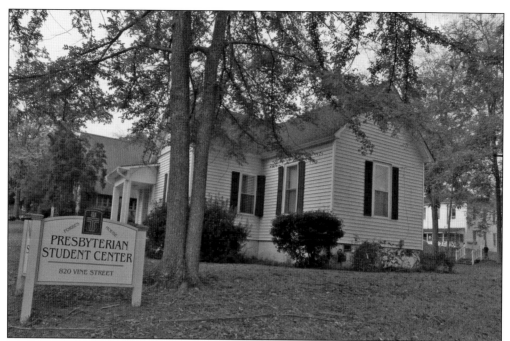

In 1947, Montevallo Presbyterian obtained the Forbes House and repurposed it for use as a student center. The house sits at the corner of Valley and Vine Streets. (Courtesy of Clark Hultquist.)

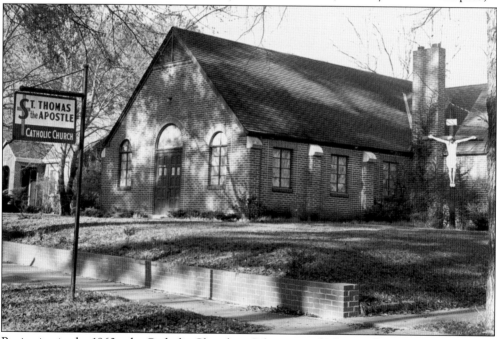

Beginning in the 1860s, the Catholic Church in Selma treated Montevallo as a mission outpost. For many years, Catholics met at the Kroell Home on Montevallo's Main Street. St. Thomas the Apostle Catholic Church, built on the corner of Highland and Moody Streets in 1951, became the parishioners' new home. In 1991, the church moved north of Montevallo, with the original structure (seen here) serving as a student chapel and a campus ministry center.

Following the Civil War, black members of several differing congregations created Ward's AME Chapel in 1872. A local boarding house presented the congregation a bell to gather their parishioners. Today, the church stands at West and Valley Streets. (Courtesy of Aldrich Coal Mine Museum.)

Montevallo Church of Christ, founded by Mary Hood, first began meeting at the Girl Scout House in 1936. Mary Hood and her husband were house parents for Napier Hall. Built in 1954, the current church sits at 830 Vine Street. (Courtesy of Aldrich Coal Mine Museum.)

University Baptist Church first organized its congregation in 1971, meeting in the Montevallo Presbyterian Church and later St. Thomas the Apostle Catholic Church. By 1973, the congregation met in its own, new building on the corner of Overland and Shoshone Streets. (Courtesy of Clark Hultquist.)

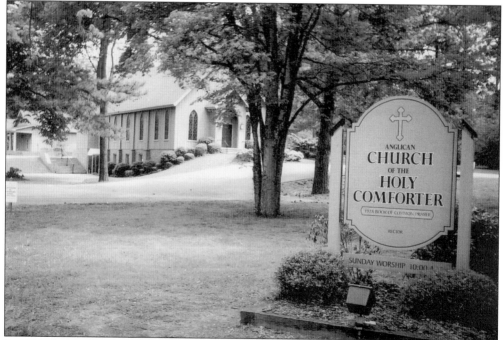

In 1983, the Anglican Church of the Holy Comforter formed and held early services in James M. Seaman's barn until construction of a new facility in 1988. This Gothic-style building houses a Holtcamp Martini organ procured from Syracuse University's music program and an English-style pulpit, purchased at an antique shop in Calera. (Courtesy of Aldrich Coal Mine Museum.)

Four

AGIS AND AGTI

A confluence of factors brought higher education to Montevallo toward the close of the 19th century. These included the town's location at the center of the state, a rail line, buildings empty and ready to be used, the need to educate young women for practical and technical careers, motivated merchants and townspeople, and some legislative assistance. All of these came into play by 1893 when the Alabama State Legislature passed a bill to establish the Alabama Girls' Industrial School (AGIS). The provisions of this act formed a Board of Trustees, and in 1895, this board chose Montevallo to be the locale of the new school.

While the early curriculum did focus on technical skills such as typewriting, dressmaking, and scientific cooking, the school's leaders wisely broadened the coursework to include English, History, Art, and Mathematics. While not officially a liberal arts college, the school had many of the trappings of such an institution. Enrollment quickly rose to over 400 by 1900, requiring many young women to live off campus until adequate dormitory space could be built.

A second phase of growth began in 1910. The president moved and the Board of Trustees agreed to change the name to the Alabama Girls' Technical Institute (AGTI), starting in 1911. Four new buildings arose in the next decade, providing more space for classes and campus services. As the state of Alabama required more teachers, the institution responded, providing certification for its graduates as the decade came to a close.

These photographs are evidence of this transformation and reveal much about the character of the times, places, buildings, and people.

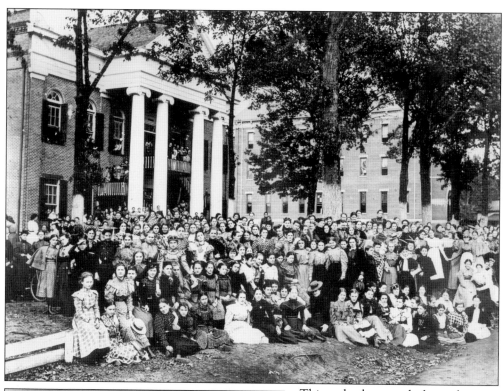

This early photograph shows the student body posed outside of Reynolds Hall and Main Dormitory. Reynolds Hall was built in 1851 on land donated by Edmund King and was used as a school, first for young men and then later adding women. In 1896, the town of Montevallo donated the building to entice the state to locate the industrial school there. Reynolds Hall served as the campus chapel and space for classes.

Julia Tutwiler (1841–1916), born in Tuscaloosa, Alabama, was the daughter of a prominent local educator. Tutwiler attended schools in both the North and Europe before returning to Alabama. Beyond teaching, she advocated for prison reform and increasing access to education for women and African Americans. Tutwiler was the Board's first choice to lead Alabama Girls' Industrial School, yet she did not serve, as she disagreed with the Board about the premature opening date.

Solomon Bloch (1855–1924), state senator from Camden, Alabama, initially proposed the legislation to create a Girls' Industrial School for the state in 1892. This legislation provided $15,000 for the establishment of the school. Bloch served on the Board of Trustees from 1895 to 1919 and helped shepherd the school through its early years when finances were a problem. Bloch was long a fixture at the institution's convocations and commencements.

Henry Clay Reynolds (1838–1920), local entrepreneur, served as the first president of Alabama Girls' Industrial School. During the Civil War, he acted as a scout and spy for the Confederacy. Later, Reynolds led the committee that campaigned to bring the school to central Alabama. After Julia Tutwiler withdrew her name from consideration, the board of trustees chose Reynolds to lead the institution in 1896. Reynolds later served as mayor of Montevallo from 1904 to 1905.

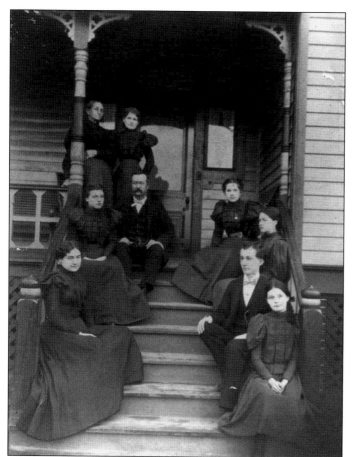

Before the completion of Main Hall Dormitory, all students boarded in private houses where campus rules still applied. The school reassured parents with the notice that a monitor, who reported to the president, would note violations, misconduct, and "any breach of table manners, and the conduct of each girl in school or out is the subject of the closest scrutiny. The arrangements of boarding girls in private families has proven very beneficial to their health."

This 1896–1897 catalog photograph entitled "At the Spring" shows "Big Spring" next to Shoal Creek. Big Spring, less than a mile from campus, provided a secondary source of water for the school.

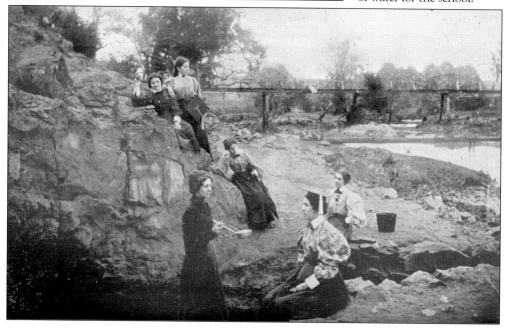

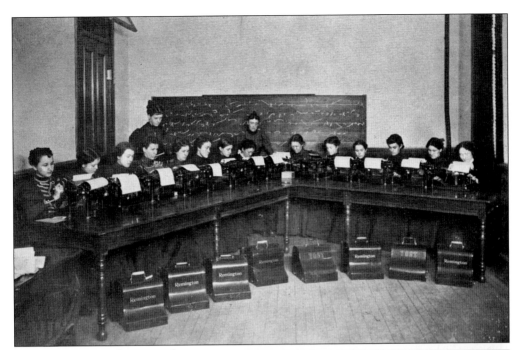

This 1897–1898 catalog image shows what is labeled the "Typewriting Department." The course in typewriting "embraces thorough knowledge of the machine" and "how to use it in such a way as to keep it from wearing out." The course gave particular attention to "orthography, punctuation, and the correct formation of sentences." The required textbook was *Barnes' Complete Remington Instructor.*

This 1897–1898 catalog photograph is entitled: "Dress for flower girl at wedding. Made in the dress-making department." Dressmaking required two years of academic work, as when students entered the school, most "scarcely knew how to use a thimble." Students learned "choice of materials, how to blend colors, how to dress artistically and practically, matching plaids and stripes, in skirt and waist pressing, and how to hang a skirt properly."

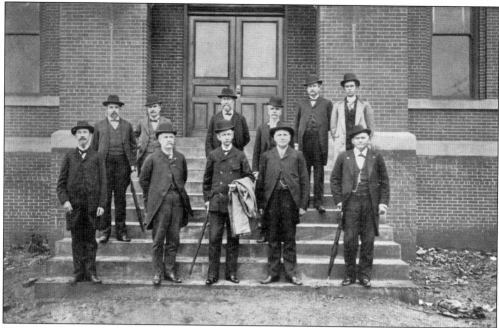

This 1898 image shows the governor of Alabama, Joseph F. Johnston, and the board of trustees of the school. The board members were A.H. Alston, H. Austill, Sol Bloch, Virgil Bouldin, G.B. Eager, W.R. Dortch, John McQueen, F.S. Moody, T.S. Plowman, and W.W. Wadsworth. In 1899, the board chose not to reelect Reynolds as president.

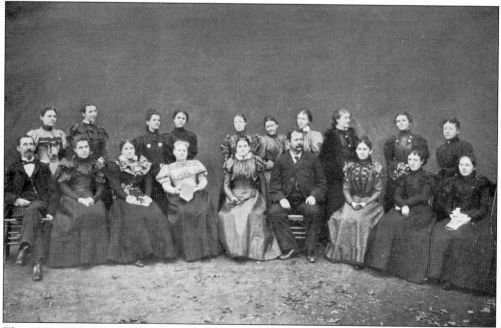

This 1897–1898 photograph shows the school's early faculty and administration. Among them are Captain Reynolds (seated on the left), Anne E. Kennedy, Elizabeth Haley, R.J.H. Simmons, Edna Bush, Addie Lee, Gussie Nelson, Nellie Evans, Florence Hudson, Mary C. Babb, and Ella McCombs. Faculty pay was $60 a month.

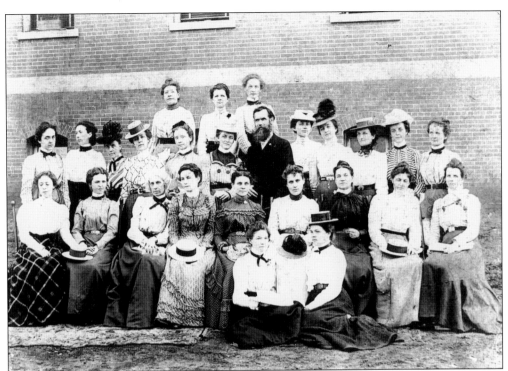

This photograph shows President Peterson (center), along with other faculty and staff of the school in 1899. Notable figures include Mary Babb, principal and natural science teacher (seated seventh from left); Mary Goode Stallworth, mathematics (standing second from left); Anne E. Kennedy, English and history (standing third from left); and Elizabeth Haley, pedagogy (standing fifth from left).

Francis Marion Peterson (1854–1908) served as the second president of the Alabama Girls' Industrial School from 1899 to 1906. Both a minister and a classical scholar, Peterson believed the school should focus more on the liberal arts rather than just industrial training. Peterson helped secure additional state funds to ensure the school's survival in its early years.

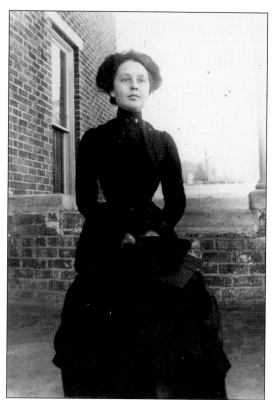

This late-1890s photograph shows a student in her dress uniform. Regulations stated "the dress uniform for fall and winter shall be of dark, navy blue cashmere, trimmed with same material and plainly made" and "an oxford cap of the same material shall be worn." The dress could be "cut, fitted, and made by the girl under the direction of the skilled dressmaker in charge of that department" as a lesson in "domestic economy."

Taken in the late 1890s, this image shows the first wing of Main Dormitory with students, faculty, and staff. At this time, the building accommodated 100 students. The school instructed students to bring to the dormitory "one pair of sheets, one pair of blankets, one pair of pillow cases, one bedspread, six towels, one clothes bag, and one pillow." Many young women at this time still lived in private residences off campus.

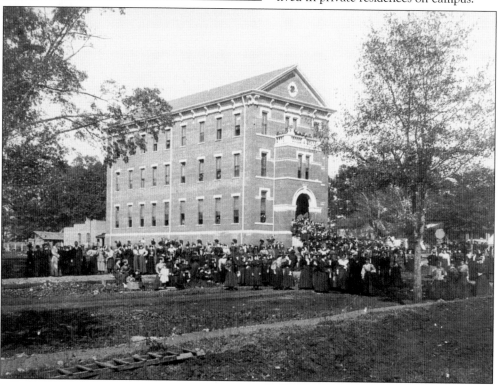

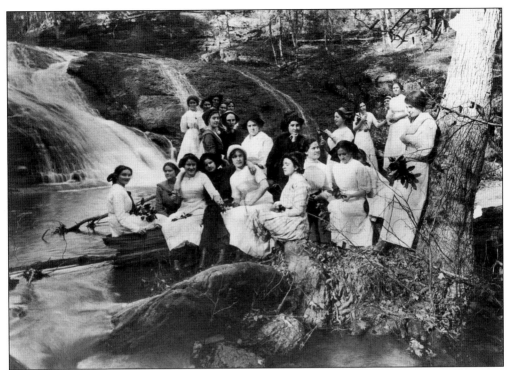

This pre-1919 image shows students at Davis Falls, located a few miles northwest of campus. Davis Falls was a popular recreation site for students, especially during the warmer months of the year.

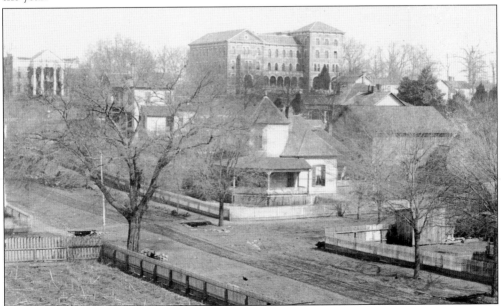

This photograph shows a view of the campus from the southwest in 1907. In the background sits Reynolds Hall (left), the first two wings of Main Hall (center), and President Palmer's home (right). The foreground shows the intersection of Valley and Middle Streets. The Lyman House sits between Reynolds and Main Halls.

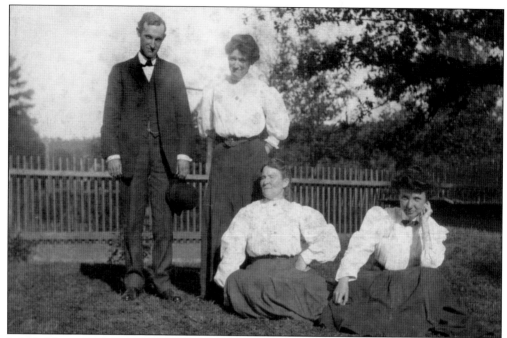

J. Alex Moore, Bachelor of Philosophy from Southern University, was chairman of the faculty in the first years of the institution and also taught penmanship and bookkeeping. In 1906, Moore became acting president during President Peterson's illness and served until the hiring of Thomas Palmer in 1907. From left to right are (first row) Mary E. McMillan, teacher of designing; and Maude E. Hayes, teacher of elocution; (second row) Moore and his wife, Anne Moore.

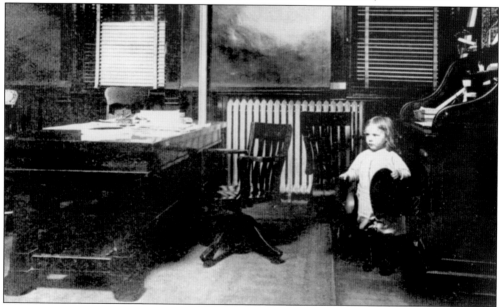

This photograph, taken in the late 1890s and entitled "Our Mascot" shows a young girl in the president's office. In addition to meeting with the governor and the board of trustees, early campus presidents found themselves engaging in civic duties, policing the campus at night, and effecting physical repairs of machinery.

This image from the 1909 *Chiaroscuro* shows the rear of Main Hall Dormitory. The structure had a tubular Kirker-Bender fire escape on the side of each wing and a tower providing pressurized water. The dormitory housed over 450 students and at its completion was one of the largest all-female dormitories in the South.

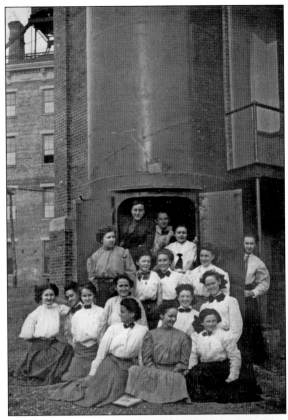

Main Hall housed the library, as seen in this 1908–1909 catalog image. The library had its origins in a gift of books by the Montevallo Studiosis. The photograph shows a piece of bronze statuary, *L'Inspiration*, by L. Pilet, given by Lillie Fair Smith. Students supported the 1,700-volume library by paying a $2 fee. The book collection remained in Main until 1923, when the school constructed a standalone library, later to be named Wills Hall.

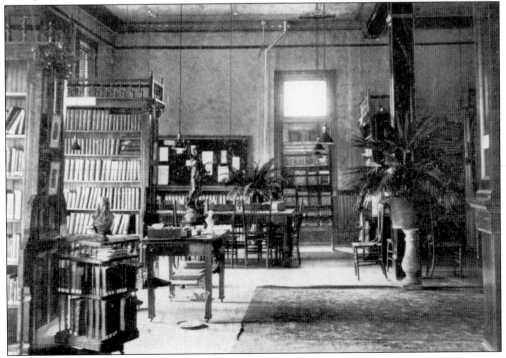

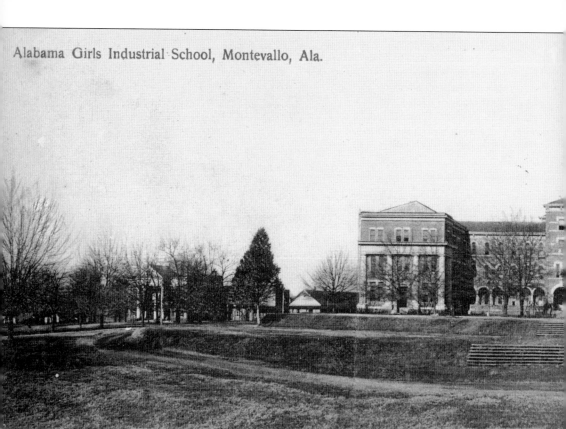

Alabama Girls Industrial School, Montevallo, Ala.

This panoramic view of campus appeared on a 1908 postcard. From left to right, the three buildings are: Reynolds Hall (still known as the Chapel), the completed three wings of Main Hall Dormitory (Haley, Kennedy, and Stallworth), and President Palmer's home. Main Hall provided modern conveniences such as "steam heat, electric lights, hot and cold water under pressure, splendid ventilation, numerous exits and fire escapes." The dormitory was "unsurpassed in its arrangement

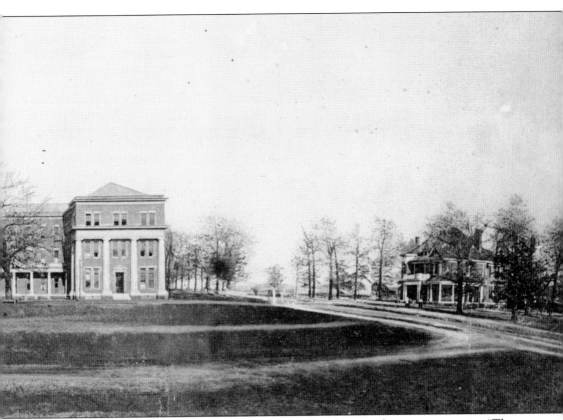

for promotion of health and comfort for students." School uniform regulations were precise: "The shirt waist must have collar attached, long sleeve with tailored cuff, and be opened in front. No trimmings (either folds or buttons) are to be used on skirts . . . Skirts must be made by Butterick pattern No. 4226 with inverted box pleat in the back, normal waist line, and a four-inch hem."

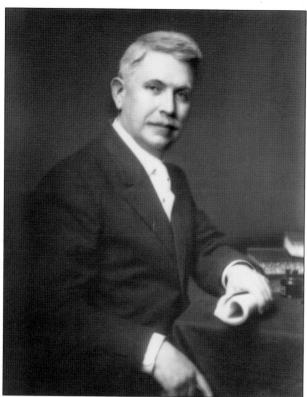

Thomas Waverly Palmer (1860–1926), earned a degree in engineering and mathematics from the University of Alabama, where he later served as dean of the Faculty of Arts and Sciences. The Board selected Palmer as the third president of the institution in 1907. Under Palmer's charismatic and able leadership, the school transformed from an industrial school to a fully accredited college with several new buildings and a significant increase in students.

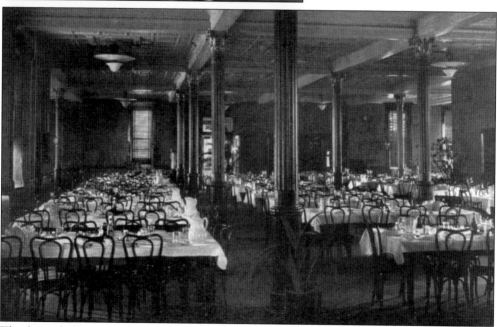

The dining hall was in the basement of central Main Dormitory. The 1909 catalog notes that the kitchen has "all modern appliances" and that selected students could pay their own expenses by working in the dining room. A "trained dietitian has charge of the selection and preparation of all the food" to ensure that the "students may have a wholesome, well-prepared and varied diet."

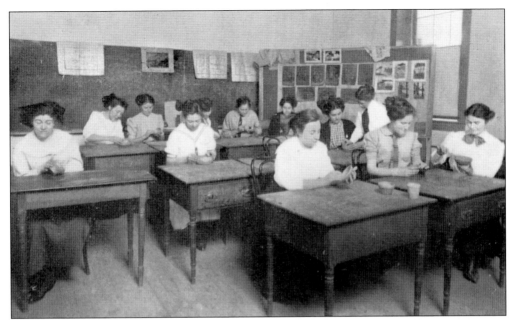

Clay modeling, as seen in this 1910–1911 catalog photograph, took place in all four years of the art curriculum. The students fired their work in a "No. 6 Revelation China Kiln." Yearly promotion required an annual examination before a student was passed to the next class.

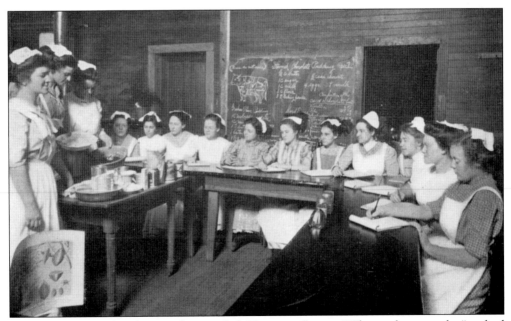

This 1910–1911 catalog photograph is entitled: "Domestic Science." The catalog notes the "method taught is the most practical one, comprising a thorough classification and chemical analysis of food products." Selected classes "give a luncheon, dinner, or tea to invited guests, which thus affords them the opportunity of demonstrating the art of serving as well as of preparing dainty dishes."

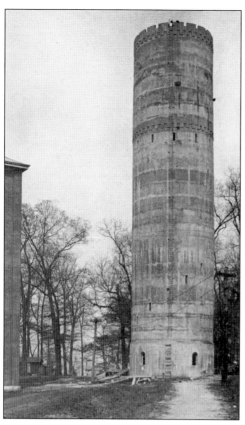

This 1910–1911 catalog photograph shows the campus water tower, simply known as the "Tower." Fed from a campus-owned spring, the Tower had a capacity of over 100,000 gallons, which not only serviced the school but the town as well. In 1962, with the completion of a new water tower, the school converted the Tower into offices for student publications on campus.

This photograph shows the Philodendroi Lodge, constructed by students from 1907 to 1910. The 1921 *Technala* yearbook notes the lodge's purpose was to impress upon students "the value of natural resources, and to show the members what a wonderful storehouse nature provides for those who seek to study her natural resources." The lodge, no longer standing, sat near today's presidential residence, Flowerhill.

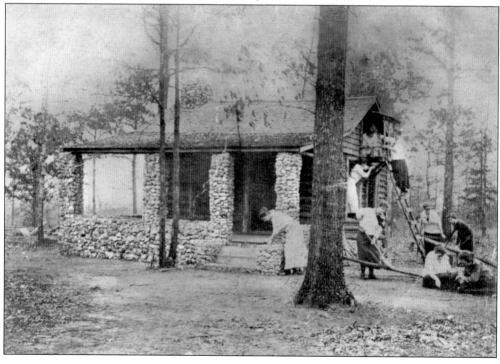

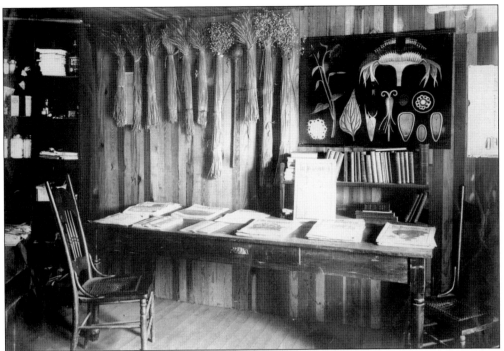

The school's early years saw much emphasis on technical education. This 1913 photograph from the campus manual on agricultural education was entitled: "Suggestions for an agricultural reading table." Such a table would ideally sit in the corner of a classroom and provide reference material and resources for agricultural study. The reading table could form the eventual basis for a school's larger agricultural library.

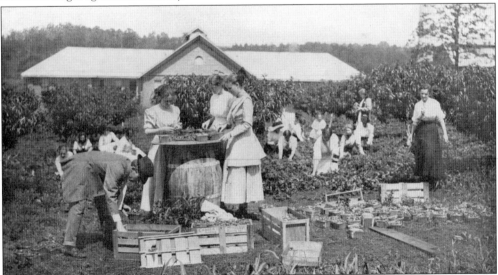

This 1914–1915 catalog photograph shows students picking and packing strawberries. Courses in agriculture focused on practical application of techniques. The catalog notes that "agriculture meant nothing to a girl until the class picked ripe strawberries in the school garden and sorted and packed them into crates. Maybe we would analyze it as the creative spirit appealing to her. At any rate she now finds pleasure and profit in growing strawberries at home."

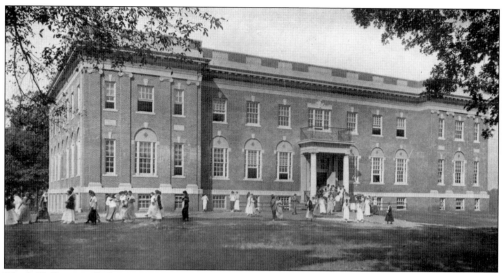

Bloch Hall, named after trustee Solomon Bloch, opened in 1915 at a cost of $60,000. The structure became the school's third major building and the first on campus expressly for academic work. Bloch provided welcome relief for cramped class space as the new building housed laboratories, rooms for domestic science classes, and studios for the fine arts. Today, Bloch houses both the Departments of Art and Family and Consumer Sciences.

The 1915 catalog described the merits of the newly constructed Bloch Hall as including "fireproof construction throughout, equipped with modern plumbing, steam heat, electric lights, and gas." Furthermore, "it is probably the best arranged and most thoroughly equipped building for Home Economics in the entire South." This photograph shows a recitation room.

Charles Calkins (1887–1921), a native of Massachusetts, studied at the New England Conservatory of Music. As director of the Department of Music from 1913 to 1921, he transformed music education at the institution by enlarging course offerings on theory, harmony, technique, sight-reading, and ear training. Calkins planned for graduates "to become musical leaders in the lives of the communities in which they will reside."

Calkins Hall opened in 1917, providing space for the growing Department of Music. The building, one of the loveliest on campus, was built in a Colonial Williamsburg style with representations of stylized musical instruments in its interior decorations. The new building allowed the expansion of the music program with room for studios and a concert hall. Today, Calkins Hall houses the University of Montevallo administration.

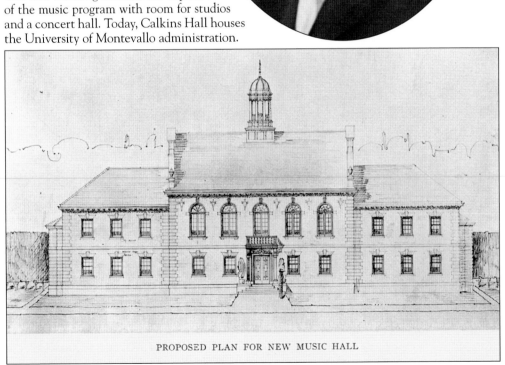

PROPOSED PLAN FOR NEW MUSIC HALL

59

Peterson Hall, completed in 1914, long served as the campus infirmary. Use of the building prevented widespread outbreaks of illnesses by quarantining students away from Main Hall. The infirmary provided appropriate space for medical treatment with room for 36 patients and apartments for a nurse and the campus physician. Today, Peterson Hall houses studio space for the Department of Art.

Myrtle Brooke (1872–1948) joined the college in 1908 as chair of the Department of Psychology and Education. In the 1920s, Brooke developed the first undergraduate program in social work in the Southeast, starting a long tradition at the school. College Night was dedicated to Brooke in 1942. The Alabama Women's Hall of Fame inducted Brooke into its ranks in 1979.

Five

ALABAMA COLLEGE

The school's third president, Thomas Waverly Palmer, championed the transformation of the school from a technical institute to a full-fledged college, which it became in 1923. Over the next 40 years, the institution put down deep roots and many of the contemporary buildings now bear the names of the men and women who were the leaders of this era. Long-time traditions such as Crook Week, Elite Night, May Day, and College Night all began or became institutionalized in this era. The school newspaper, the *Alabamian*; the yearbook, the *Technala*; and a literary magazine, the *Tower* were excellent examples of a literate, clever, and creative female student body. Perhaps the most influential of the institution's presidents was Oliver Cromwell Carmichael, who led the school between 1926 and 1935. Carmichael built upon his predecessor's accomplishments and truly made Alabama College one of the finest women's colleges in the nation. He did so by hiring faculty from prestigious institutions, broadening the curriculum, increasing enrollment to nearly 1,000, earning accreditation from the Southern Association of Colleges and Schools, and spreading the physical footprint of the campus.

The school broadened the cultural world of its students and the community, attracting luminaries such as Carl Sandburg, Martha Graham, Will Durant, Douglas Southall Freeman, Margaret Bourke-White, Dumas Malone, and Lewis Mumford to speak or perform on campus. Carmichael and his successors continued to strengthen the school's liberal arts tradition, attracting talented faculty and activists for social justice such as John R. Steelman and Hallie Farmer. The school recruited international faculty as well, including Polish pianist Miecislaw Ziolkowski and English author Robert Payne.

By 1955, facing declining enrollment, the president and board made a crucial decision: the college would allow men to attend in the fall of 1956. This change and the fruits of the baby boom in the 1960s witnessed all-time high enrollments at the school and another massive wave of campus building.

The images in this chapter reflect the vitality and the dynamism of the college and its institutional changes. These photographs capture the colorful personalities and long-lasting effects the school has had on its students and the community.

Funds raised during the "Million Dollar Drive" allowed the construction of Ramsay Hall in 1925. Mining engineer and philanthropist Erskine Ramsay had donated $100,000 to the drive and subsequently the college named the building in honor of his mother. It was the second dormitory built on campus and could house 200 students. The late 1970s saw the building remodeled and transformed into a conference center.

Flowerhill, built in 1926, has been home to 12 presidents of the college. At the end of campus on a pecan tree–lined street, the home sits on top of a hill where Spring Commencement now takes place. Known formerly by a variety of names, the term "Flowerhill" comes from the efforts of several presidents' wives who expertly landscaped the grounds, cultivating the beauty of the location.

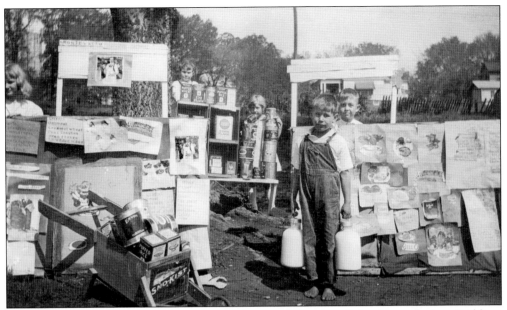

This 1928 photograph was taken outside the Education Laboratory School, now the Jeter Building. The college newspaper, the *Alabamian*, noted that elementary education at this time aimed for more informal classrooms as "these girls and boys enjoy projects suited to their age such as gardening, banking, and local interests, while the little children build houses, stores, moving pictures, and radios." This photograph shows students running a model grocery store.

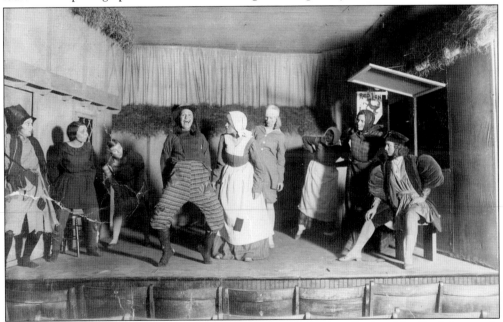

In October 1929, Alabama College produced *Gammer Gurton's Needle*, the oldest English comedy extant, in Reynolds Hall. In the foreground are (left) Helen Mahler as "Hodge" and Leila Ford as "Gammer Gurton." The cast also included Florence Stevens, Inamurl Smith, Mary L. Russell, Christine Purefoy, Louise White, Annie Bledsoe, Evelyn Leak, Floyce Griffin, and Winnie M. Troomer. After this production, plays opened in the newly built Palmer Hall.

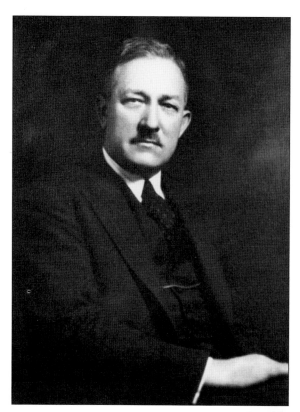

Oliver Cromwell Carmichael (1891–1966) served first as dean and then as president of Alabama College. A graduate of the University of Alabama and a Rhodes scholar, he led the "Million Dollar Drive" to raise funds for Alabama College in 1924. Carmichael's successful presidency emphasized academics over vocational training by broadening the curriculum, recruiting faculty nationwide, and gaining collegiate accreditation. The campus expanded both in enrollment and physical size during his tenure.

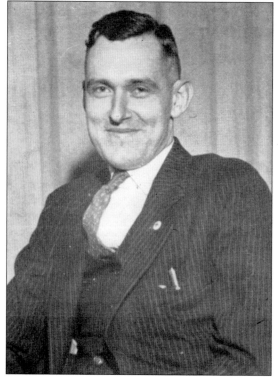

John R. Steelman (1900–1999), popular professor of sociology, taught at Alabama College from 1928 to 1934. An expert in mob violence, Steelman advocated social and labor justice in Alabama. After US Secretary of Labor Frances Perkins's 1934 commencement address, she was so impressed by Steelman that she requested he work for her department. Later, he served as the assistant (chief of staff) to President Truman.

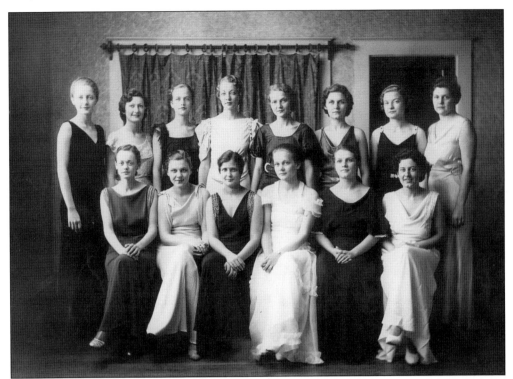

Elite Night was a longtime tradition at Alabama College beginning in 1933. Students voted for candidates, vying for eight individual titles: "Miss Alabama College," "The Athlete," "The Society Woman," "The Business Woman," "The Musician," "The Actress," "The Writer," and "The Artist." An outside "celebrity" judge chose an additional four women to serve as campus "beauties." By the late 1950s, Elite Night became an academic honorary society where individual departments selected the winners.

Alabama College awarded a Bachelor of Arts degree to Ladean DeSear Baldwin in 1936. The diploma bears the signatures of Gov. Bibb Graves and college president Arthur Fort Harman.

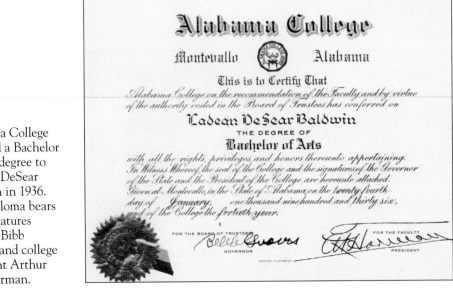

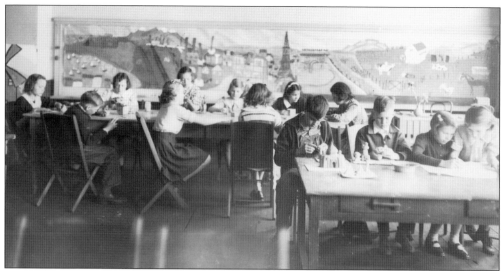

This 1938 interior view of the Education Laboratory School depicts a demonstration group in the lower grades. This is an art class receiving instruction in clay modeling.

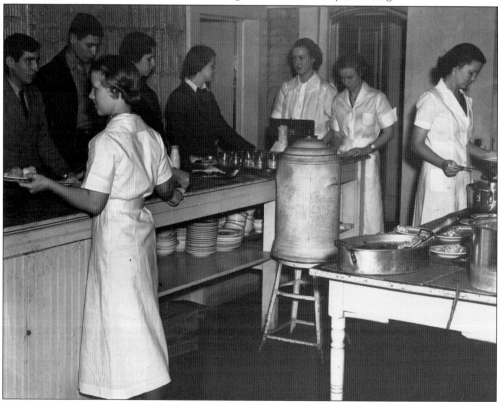

This 1938 photograph shows the cafeteria in the basement of the Jeter Building. The cafeteria served meals to both the elementary and high schools. Erected in 1915 at a cost of $10,000, the building served dual roles as the town elementary school and a place where education majors could gain practical experience. This training school allowed future teachers to earn certificates while observing qualified instructors.

During the 1930s, Alabama College offered a wide range of physical education classes such as sports, gymnastics, general health, first aid, games, and kinesiology. A class available for sophomores, juniors, and seniors was entitled Prescribed Rest. This course was "required of all who are unable to take general work and for whom the need of rest is indicated by their physical condition. Five hours a week. Credit, 1 hour each semester."

This 1938 *Technala* image shows a freshman soccer class. Soccer was not yet an intramural sport but it "has a loyal following as shown by the large numbers signing up for the class each fall." On the left one can see the rock wall encircling King Cemetery and in the center the apartment house currently known as Casa Bonita. The sciences building Harman Hall now stands upon this playing field.

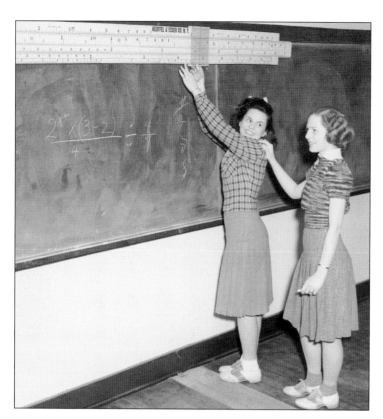

This 1940s photograph shows two students in Bloch Hall factoring an equation with the help of a slide rule. The mathematics curriculum of this era included solid geometry, analytic geometry, the mathematics of finance, spherical trigonometry, differential and integral calculus, theory of equations, and differential equations.

Olivia Lawson, longtime professor of education, earned her bachelor's degree from Peabody College and a master's from Columbia University. She is shown in this 1940s photograph demonstrating the use of a "teaching machine" to Alabama College students.

This Alabama College Dairy Farm photograph, taken in the 1940s, shows part of the school's 200-acre farm. The college owned over 100 head of registered Jersey, Guernsey, and Holstein cows that supplied the campus with high-quality fresh milk, butter, and cream. The farm's ice cream was long one of the campus favorites. In 1959, the college quit the dairy business, selling off the cows and converting the barns into faculty housing.

This 1940s photograph shows the college Power House. The campus bulletin notes that the Power House "is equipped with modern heating and lighting equipment and supplies heat and light to the other buildings on campus. The plant is operated by skilled engineers in a highly efficient manner." Adjacent to the Power House was the campus laundry, "equipped with modern machinery" and "in charge of an expert." Also, the kitchen used steam for food preparation.

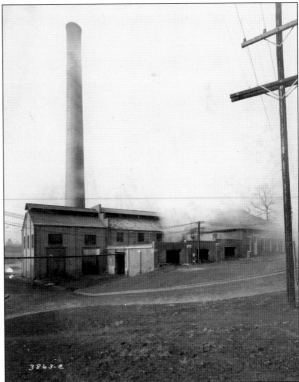

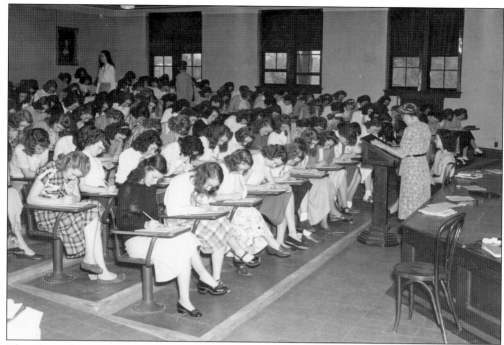

This 1940s photograph shows psychology professor Minnie Steckel at the lectern. Steckel started her career as principal of a two-room school and eventually did her graduate work at the University of Chicago, earning a doctoral degree in psychology. Hired as a student counselor, Steckel played the "dual role of psychology teacher and student counselor. Harassed students seek her good word on all kinds of problems from financial worries to roommate quarrels."

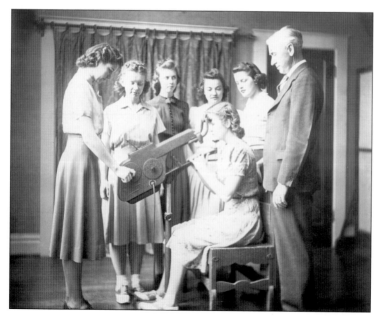

Holding a doctorate from Columbia University, J.I. Riddle was professor of education and director of the Home Study Service from 1928 to 1943. He is shown here instructing students in the use of teaching equipment. A college bulletin of 1940 noted, "Alabama College graduates recently placed for teaching positions began teaching at monthly salaries ranging from $85 to $120."

This 1940s photograph shows an Alabama College student using a Dictaphone. The Department of Secretarial Science offered a broad curriculum of courses including shorthand, typewriting, machine operation, business organization, advertising, insurance, money and banking, accounting, and principles of economics.

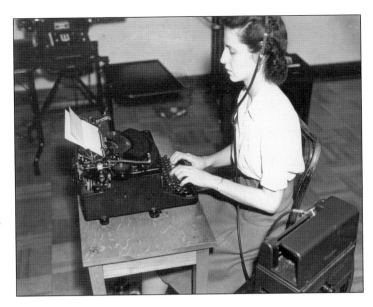

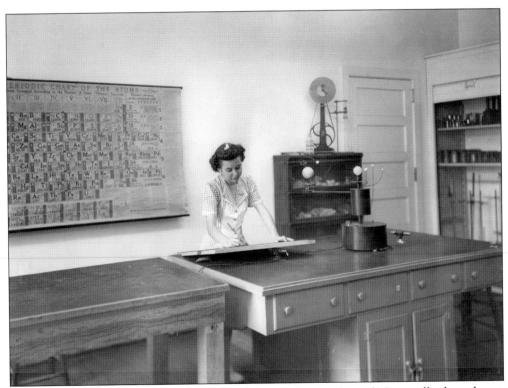

This 1943 photograph of Alabama College student Helen Gardner of Montevallo shows her at work in a science laboratory. According to the alumnae newsletter, Gardner was an art major but took extra classes in mathematics and chemistry. As she noted, "taking such extra studies as I think will give me a basis of knowledge in as many fields as possible related to my plans."

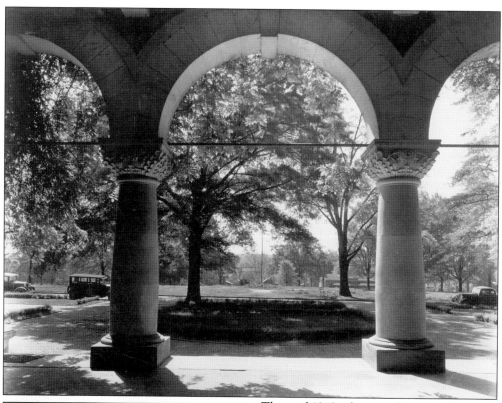

This mid-1940s photograph is a southward-facing view from the Kennedy Wing of Main Hall. Visible at the bottom of the steps is evidence of the college's paving of sidewalks and streets with its now-signature red brick. Before this paving, campus roads were generally dirt and gravel.

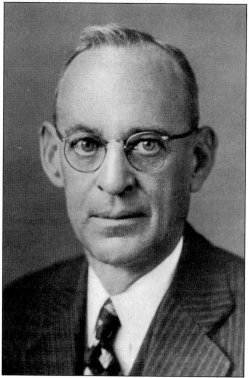

Edward Houston Wills, with degrees from Alabama Polytechnic University and Cornell University, was the longtime purchasing agent, registrar, and business manager of Alabama College from 1909 to 1946. Wills also instructed in history and business law. His obituary read, "He had a warmth and an honest humanity that drew students to him for friendship and counsel." Shortly after Wills's death, the college renamed the campus library in his honor.

Robert Payne (1911–1983) was born in Cornwall, England. From 1941 to 1946, Payne lived in China, where he served as cultural attaché to the British Embassy. Payne taught at Alabama College from 1949 to 1953, where he served as chair and professor of English and author-in-residence. A prolific author, Payne wrote over 100 books covering literary, historical, cultural, and political topics. In 1950, the *New York Times* named Payne as America's "most versatile writer of the year."

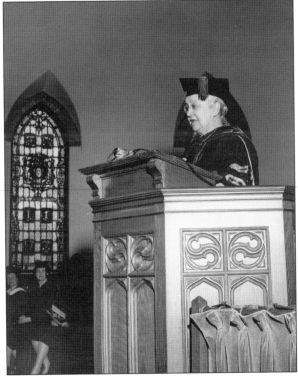

Hallie Farmer (1891–1960) earned her doctorate in history from the University of Wisconsin and joined Alabama College as head of the Department of History in 1927. In Farmer's nearly 30 years on campus, she was one of its most active voices for social justice including prison reform, eliminating the poll tax, and women's rights. The first three women inducted into the Alabama Women's Hall of Fame were Helen Keller, Julia Tutwiler, and Hallie Farmer.

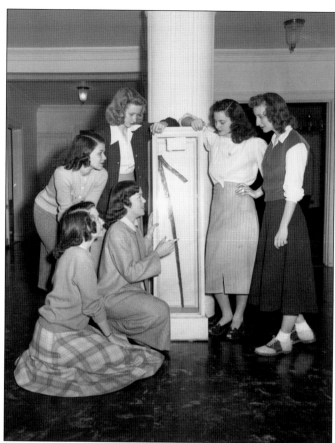

A longtime tradition of Alabama College was "Crook Week." A hazing ritual, seniors hid a crook on campus and required juniors to find it. Once the juniors found the crook and passed (or not) various other trials and tests, the seniors would then grant them the right to become seniors. A 1945 student handbook read, "The Crook is no ordinary stick. It is a symbol of responsibility and superiority in every campus activity."

The college established the dance organization Orchesis in 1936. Orchesis performs twice a year and also tours and gives guest performances. The organization also handles all the elements of dance production including props, costumes, multimedia elements, and lighting.

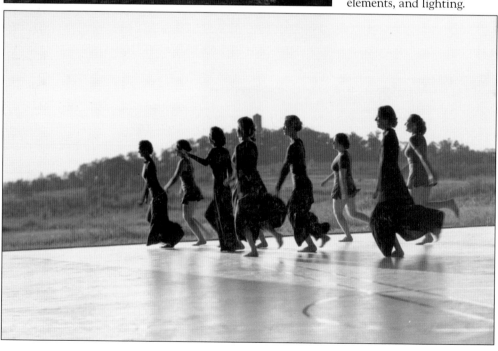

This 1945 photograph shows the "loafing porch." The porch was adjacent to the Old Tea House in Reynolds Hall, and served both as a student union and the only place on campus to buy snacks and beverages. The "loafing porch" was a popular social destination for students, faculty, and staff until the 1960s, when a new student union was constructed.

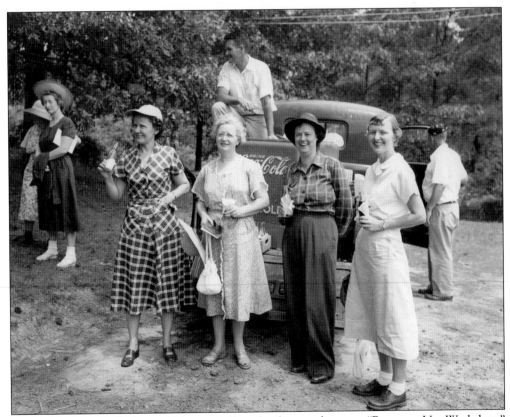

This 1953 photograph shows Alabama College faculty members at a "Resource Use Workshop." The month-long workshop was designed to promote more efficient use of Alabama's natural resources. Teachers, professors, and state and national conservationists gathered in Montevallo to explore forests, dairies, cattle farms, and experimental nurseries.

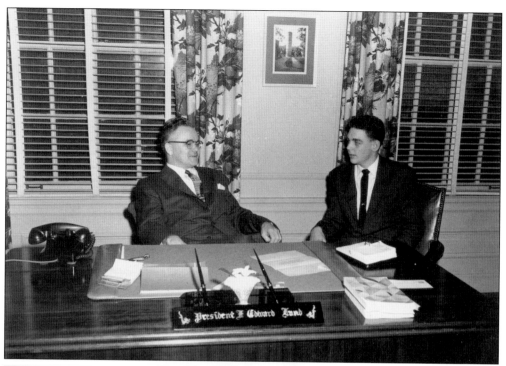

Franz Edward Lund (left) was president of Alabama College from 1952 to 1957. Prior to his tenure, the school had faced dwindling enrollment. During Lund's administration, the college began to offer graduate work and officially welcomed men as a way to boost numbers. Kenneth Holcombe (right) was one of the first male students admitted in 1956.

When Alabama College officially opened its doors to male students in 1956, the school needed a new residence hall. Named after longtime dean of the college T.H. Napier, the building opened in 1957. Costing over $600,000, this "modern" building housed 180 male students and boasted air conditioning and direct-dial telephones in every room.

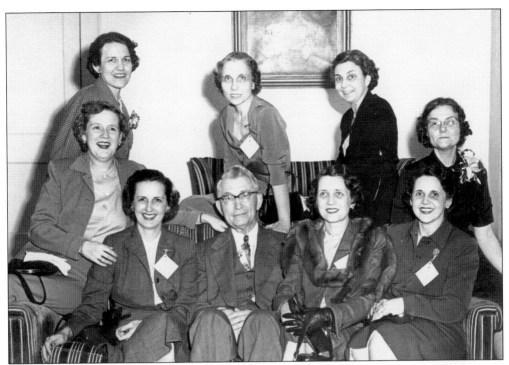

This 1955 photograph shows the 25th reunion of the class of 1930 and popular dean of Alabama College Thomas Hewell Napier (1881–1961), who served from 1926 to 1952. He and Mrs. Napier hosted an annual tea for seniors at their home each April. From left to right are (first row) Frances Lewis Givhan, Laurice Butler Walthall, Dean Napier, Lucy Holcombe Salter, and Edith High; (second row) Leila Belle Ford, Louise White, Fannie Stollenwerck, and Natalie Molton.

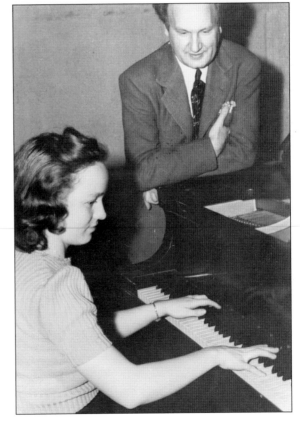

Miecislaw Ziolkowski was professor of piano at Alabama College from 1929 to 1959. He was born in Poland and studied in Switzerland with Ignacy Paderewski and later earned his Master's degree from the Stern Conservatory in Berlin. Ziolkowski was known for his annual piano recital in January and his occasional performances on the campus radio station WAPI.

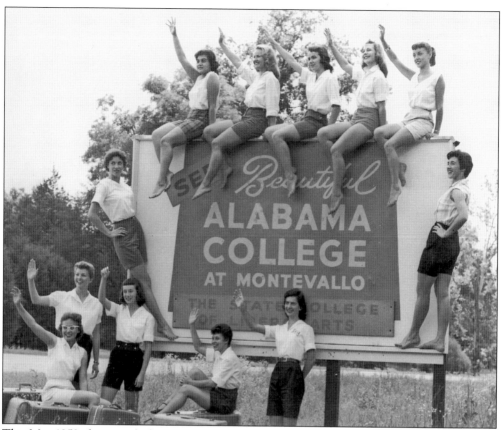

This May 1959 photograph shows Alabama College students waving goodbye as they finish the school year. The students are, from left to right, (first row) Linda Sparkman, Jo Ann Baites, Elnora DeVaughn, Pat Smith, and Nan Jackson; (second row) Frances Whorton and Annette Cataldo; (third row) Edna Avers, Lucy Weeks, Loretta Little, Betty Frost, and Joyce Willis.

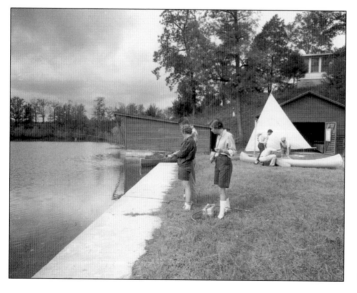

In 1950, Alabama College announced plans to build a 12-acre lake north of campus. Besides serving recreational purposes, the college used the lake for water safety instruction and bait casting courses. A faculty clubhouse stood beside the lake. This c. 1957 photograph shows professor Miriam Collins (center), unidentified, Bonnie Strickland, Bobby Harrison, and two unidentified

Wills Hall (seen here) housed the college's library since 1923 but by the 1960s, the building was too small to host the increasing numbers of students and the library's collection of materials. In 1968, Oliver Cromwell Carmichael Library opened its doors, with students and faculty transferring the books over a weekend. The new building could hold over 250,000 books and seat over 800 students.

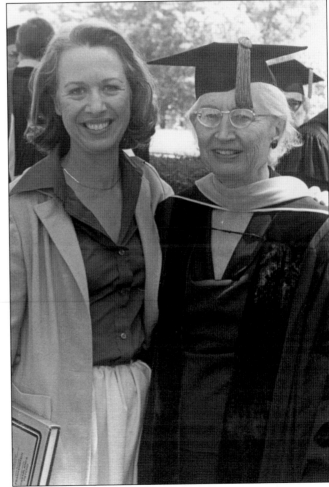

Polly Holliday (left) of Jasper, Alabama, graduated from Alabama College in 1959 with her bachelor's in piano, studying under Dr. Maxine Couch Davis (right). On campus, Holliday starred in the lead role of *Hedda Gabler*. After graduation, Holliday found fame on Broadway and in Hollywood, starring in the television series *Alice*, where she won two Golden Globe Awards for Best Supporting Actress. The Alabama Walk of Fame inducted Holliday into its ranks in 1989.

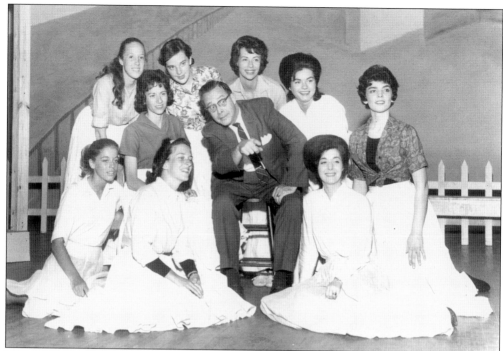

W.T. Chichester, professor of speech and theater, was a veteran of over 300 productions, more than 30 of them at Montevallo between 1960 and 1980. In the 1930s, he was a radio actor for the *Philip Morris Hour* with Orson Welles. During World War II, he served in the Entertainment Branch of the Army Special Services. The Chichester Black Box Theater, or the "Chi Box," is named in his honor.

Named after the college's fifth president, Arthur Fort Harman Hall was one of several buildings added to campus during the 1960s. Bloch Hall had previously housed most of the sciences and by this time space was inadequate and laboratory facilities antiquated. The new structure, built at a cost of over $1 million, added over 20 laboratories to the campus. The building's central courtyard features an 8-ton geode.

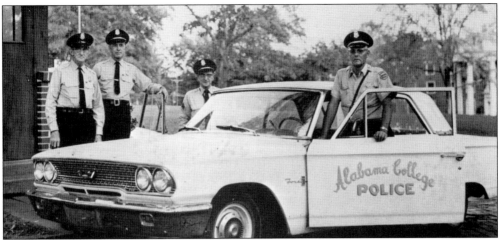

As with most colleges, Alabama College developed its own policing independent of the city of Montevallo. This 1964 photograph from the *Montage* yearbook shows the campus police. With the physical expansion of campus and an increasing number of automobiles, the force's main role was traffic safety. The 1965 faculty handbook stated, "The campus police are responsible for enforcing parking regulations and no provisions are made for ticket fixing."

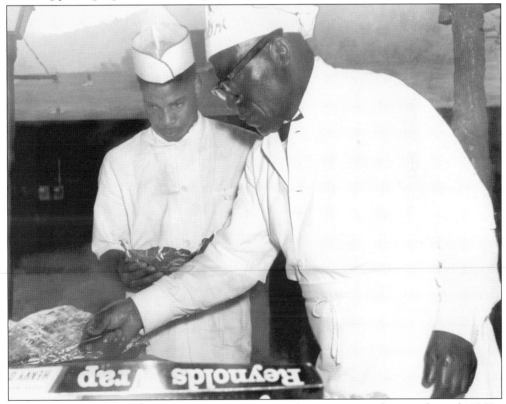

Charlie Dobbs (right) and assistant are preparing meat for a campus cookout in the early 1960s. Food arrived by freight, as the only local product was milk from the campus dairy. Weekly, the kitchen bought and prepared some 2,000 pounds of meat for over 700 students. At this time, the food service was "family style" where 54 student employees served meals to tables of eight.

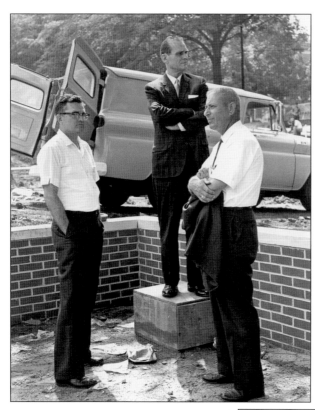

Delos Poe Culp served as college president from 1963 to 1968. With his lobbying for state and federal funds, the college experienced its most expansive building campaign, with seven new structures. Culp also emphasized academic achievement by rewarding faculty members who obtained their doctorates with salary increases. From left to right are Lee Barclay, business manager; D.P. Culp; and Kermit Mathison, admissions standing outside of Farmer Hall during its construction.

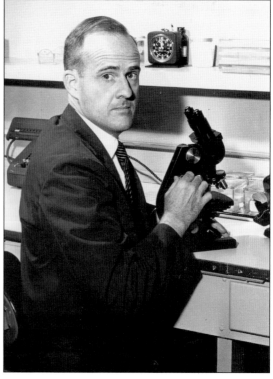

Eugene Bondurant Sledge (1923–2001) was a biology professor and author. He earned his doctorate in zoology at the University of Florida. Critics consider his best-selling memoir *With the Old Breed: At Peleliu and Okinawa* one of the finest works of 20th-century war literature. Sledge's book became the basis for much of HBO's 2010 drama *The Pacific*. A noted ornithologist, Sledge was popular with students for leading bird-watching tours of the area.

Six

University of
Montevallo

The growth of the campus and the student body in the 1960s saw another change for the institution: the state legislature approved the renaming of Alabama College as the University of Montevallo starting in 1969. By 1973, the university would have four colleges: Arts and Sciences, Business, Education, and Fine Arts. The National Council for Accreditation of Teacher Education accredited the College of Education, and master's degrees were offered in all of the colleges—the most recent being the Masters of Business Administration in 2010.

The mission of the university, however, remained constant, with its goals for much of the century to "provide students from throughout the State an affordable, geographically accessible 'small college' public higher educational experience of high quality with a strong emphasis on undergraduate liberal studies and with professional programs supported by a broad base of arts and sciences, designed for their intellectual and personal growth in the pursuit of meaningful employment and responsible, informed citizenship." Despite the university's growth, the class sizes remained small and the institution prided itself on close faculty mentoring of students.

The 1990s saw the school join the prestigious Council of Public Liberal Arts Colleges, a consortium of 26 institutions that "drives awareness of the value of high-quality, public liberal arts education in a student-centered, residential environment." At the same time the university joined Division II of the National Collegiate Athletic Association and a new athletic facility, the Robert M. McChesney Student Activity Center was built, propelling the school to athletic excellence.

Meanwhile, despite the construction over the century, the university remained true to the original Olmsted development plan as campus streets and buildings remained mostly brick. Spring days on campus are more than lovely with wisteria and azaleas in bloom and an accompanying canopy of majestic oak and pecan trees, making the campus one of the loveliest in the Southeast.

The following images will give the reader a sense of both the transformation and the continuity that this academic institution has participated in over the last 40 years.

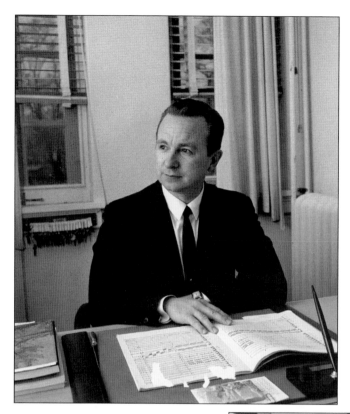

John W. Stewart, professor of music, joined the school in 1961. During his long tenure, he was chair of the Department of Music, dean of the College of Fine Arts, and finally the university's 12th president in 1988, serving until 1992. Stewart performed with the Alabama Symphony Orchestra and was a guest conductor of the Alabama Pops Orchestra. The university named its student retreat center in his honor.

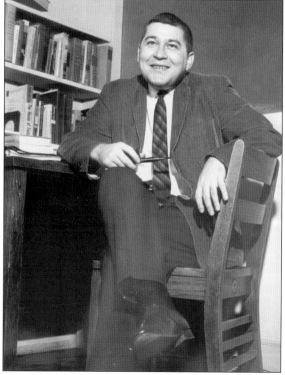

William Cobb, who earned his master's in English from Vanderbilt, served as writer-in-residence for over a dozen years. His novel *A Walk Through Fire* was nominated for the 1992 Pulitzer Prize. Cobb has authored six novels and many plays and short stories. Cobb's writings have seen him as a finalist for the Robert Kennedy Award, the Lillian Smith Award, and the PEN-Faulkner Award for fiction.

Kermit Andrew Johnson became the 10th president of the university from 1968 to 1977. Before heading Montevallo, Johnson served as superintendent of the Jefferson County Board of Education.

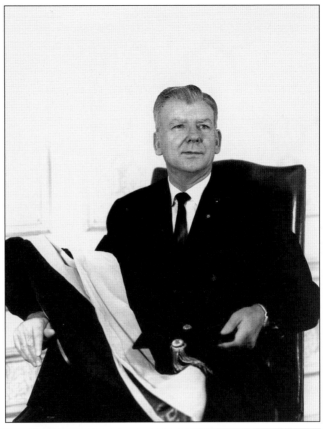

Ethel Hall came to the University of Montevallo in 1971 and was the first African American professor on the faculty. She earned her Bachelor's degree from Alabama A&M University and her Master's degree in social work from the University of Chicago. Later, she taught at the University of Alabama, where she earned her doctoral degree. Currently, Hall is a vice president of the Alabama State Board of Education.

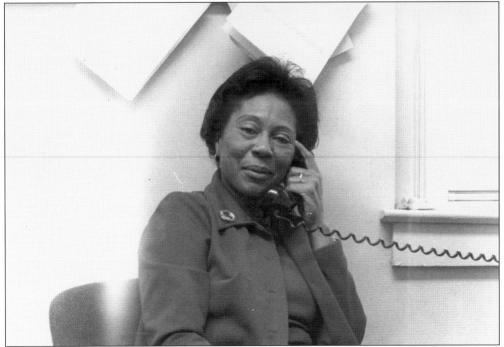

In early May, Spring Commencement takes place on the lawn outside the president's home at Flowerhill. The university also holds commencement ceremonies in August and December.

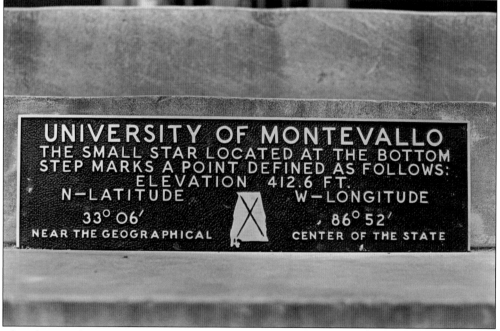

This plaque indicating Montevallo as the geographic center of the state of Alabama is laid in the steps of Main Hall. Some dispute exists about this fact as the Montevallo Chamber of Commerce constructed a marker in 1955 also attesting to this status at Reynolds Cemetery, two miles outside of the city. (Courtesy of Matthew Orton.)

Charlie Webb was a longtime staff member who delivered campus mail from 1941 to 1977. He started working at the college while in high school and never worked for another employer. A Montevallo favorite, he is shown here at his retirement ceremony in Palmer Hall.

John Phillip Lee served as the chief of police at the University of Montevallo from 1984 to 2006. He earned his master's in criminal justice administration from Troy State University, where he also worked as chief of police before joining Montevallo. Lee was an accomplished artist specializing in wildlife and birds. One of his works was chosen for the 1983–1984 Alabama Waterfowl Stamp.

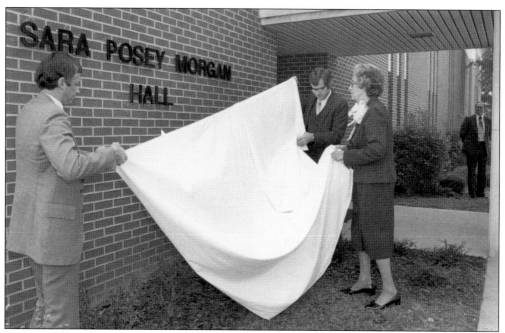

Sara Posey Morgan began her career as an instructor in the Department of Secretarial Science in 1944 and rose to the rank of professor by the 1960s. To accommodate the increase in business students, the university built a new facility in 1976. This photograph shows the 1980 dedication of Sara P. Morgan Hall. From left to right are James F. Vickrey, William Word, and Morgan. Today, the building houses the Michael E. Stephens College of Business.

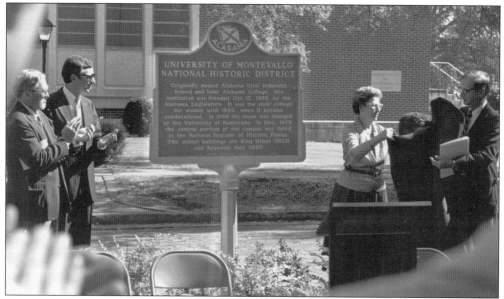

James F. Vickrey Jr. served as the university's 11th president from 1977 to 1988. This photograph shows the commemoration of the central part of campus being declared a National Historic District on Founder's Day in 1979. The drive to get such recognition was an effort to raise awareness of the university's mission to state legislators. Standing from left to right are unidentified, President Vickrey, Lucille Griffith, and Justin Fuller.

Montevallo had courses in communication disorders since the 1930s, but it was not until 1957 that the school awarded its first degree in speech language pathology. The program expanded rapidly over the next 15 years, causing the university to build the George C. Wallace Speech and Hearing Center. Montevallo is the only university in the state to offer a degree in education of the deaf and hard of hearing.

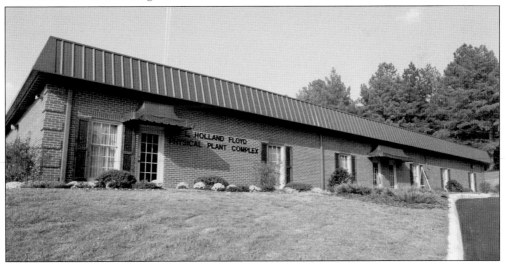

The L. Holland Floyd Physical Plant Complex, completed in 1984, was named after executive director of buildings and grounds L. Holland Floyd. Floyd brought about the installation of a central steam plant that relied on wood wastes for both heating and air conditioning. Today, the 83 employees of the physical plant division maintain the university's grounds, utilities, inventory, and mail service, supervise renovation and construction, and police the campus. (Courtesy of Matthew Orton.)

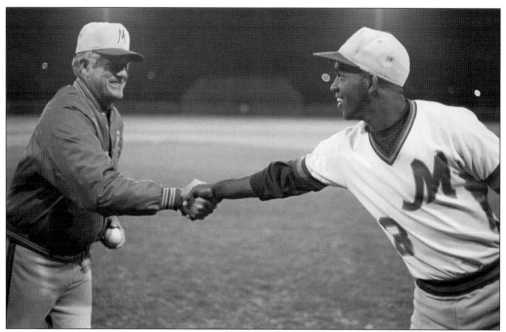

Robert "Bob" Riesener (left), seen here with player Steve Franklin, coached the university's baseball team for 30 years. Twenty-six of his players earned All-American honors. Both the NAIA and the University of Montevallo inducted him into their respective Halls of Fame as he amassed over 1,000 victories in his career. While at Montevallo, Riesener raised more than $2.5 million for the athletic program. (Courtesy of Matthew Orton.)

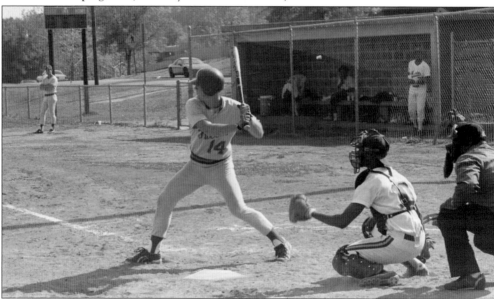

Rusty Greer of Fort Rucker, Alabama, attended Montevallo from 1988 to 1990 and starred on the baseball team, where NAIA named him a first-team All American. The Texas Rangers drafted him in the 10th round in 1990, and in 1994, his first full season in the major leagues, Greer placed third in the voting for American League Rookie of the Year. Greer went on to play nine seasons with the Rangers before retiring in 2002. (Courtesy of Matthew Orton.)

Arthur Neal Shirley was among the first men to enroll in Alabama College in 1956 and served as president of student government in 1958. He earned his bachelor's degree in mathematics and played on the school's first baseball team. Later, Shirley became director of corporate and foundation relations. The award for the school's outstanding male athlete of the year is named in his honor. (Courtesy of Matthew Orton.)

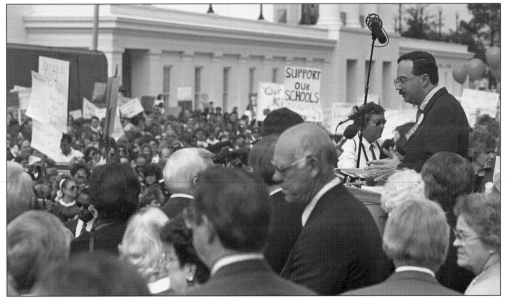

At the microphone is Thomas G. Walker Jr., class of 1975, at a state rally for higher education in Montgomery. Walker served as president of student government and worked to increase student participation in campus governance. He later served as special assistant to the president and legislative liaison at Montevallo. Currently, he is the executive director of the American Village in Montevallo and serves on the university's board of trustees. (Courtesy of Matthew Orton.)

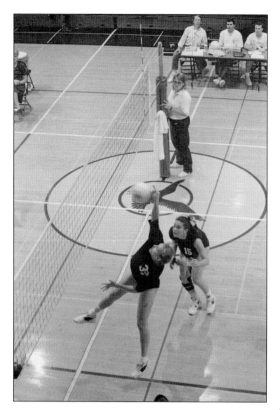

The 1992–1993 women's volleyball team, coached by Judy Green, ended the regular season with a 42-3 record, and for two months was ranked as the No. 1 NAIA team in the country. Student athlete Shawna Sauls earned First-Team NAIA All-America honors that season. (Courtesy of Matthew Orton.)

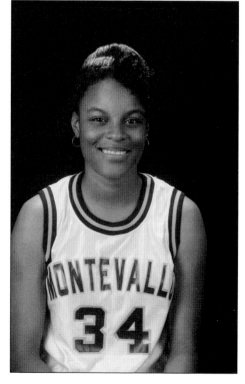

Sheena Bowling was one of the most celebrated student athletes in Montevallo's history. Twice in her basketball career, *Collegiate Sports Magazine* named Bowling its Player of the Year. In 1994, she led the Falcons to the NAIA Final Four. Bowling found herself in elite company as only the ninth woman to collect over 3,000 points in her career. The university inducted her into its Athletic Hall of Fame in 2002. (Courtesy of Matthew Orton.)

Rebecca Luker earned her bachelor's degree in music and headlined in campus productions such as *1776* and the *Fantasticks*. Soon after, she found herself starring on Broadway. Nominated for three Tony Awards, Luker has starred in performances such as *Mary Poppins*, *The Sound of Music*, *The Music Man*, *The Phantom of the Opera*, and *Showboat*. The University of Montevallo awarded her an honorary doctorate in May 2010. (Courtesy of Matthew Orton.)

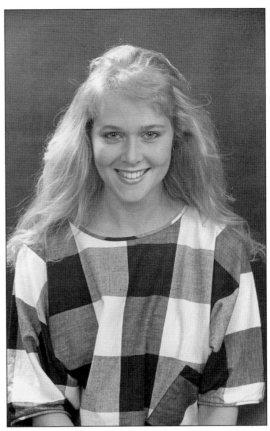

Mary Frances Tipton graduated from Alabama College in 1957, where she majored in English and was SGA president. She joined the college library in 1963 and rose to become library director. In 1996, she authored *Years Rich and Fruitful: University of Montevallo 1896–1996*; this image shows delivery of those books. Two times, students dedicated College Night to Tipton. In 1991, the university named her Montevallo's Distinguished Alumnae. (Courtesy of Matthew Orton.)

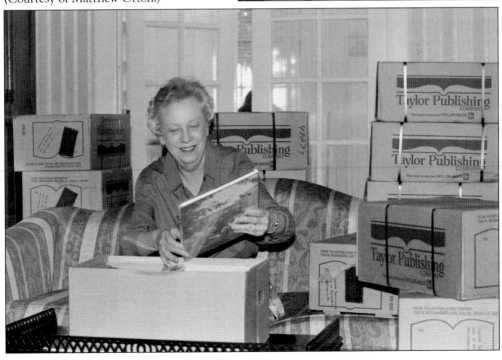

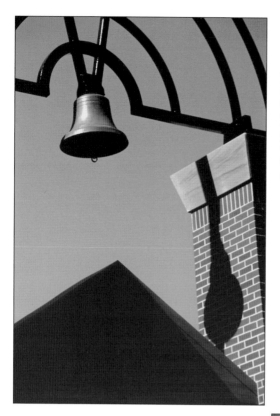

Founders' Day 1999 saw the dedication of the Bowers Colonnade. Its 1896 bell is now used to call the senior class to convocation hour on Founders' Day. Each year, faculty, administration, and the senior class line up before the colonnade's arch and proceed to Palmer Hall for the ceremony where the school's heritage is celebrated and the senior class is "robed" to mark their last year on campus. (Courtesy of Matthew Orton.)

Becoming is a 16-foot-tall bronze sculpture cast by professor of art Ted Metz and students in 2002. The artwork symbolizes the teacher/student relationship with the younger hand of the student suggesting "growth and development." The teacher's hand, once guiding that of the pupil, represents a "new role of support for the student." The keys represent knowledge. Montevallo alumnae and board member Jeannetta Keller helped underwrite the installation. (Courtesy of Matthew Orton.)

94

Anthony Pattin, professor of music, continues Montevallo's long tradition of piano excellence beginning with Miecislaw Ziolkowski. The school honored him with the College of Fine Arts Distinguished Teaching Award and named him University Scholar in 2002. He has performed with the Alabama Symphony, the Tuscaloosa Symphony, the Toledo Symphony, and the Arkansas Symphony, and has given two recitals at Carnegie Hall. In 2008, the university became an All-Steinway School. (Courtesy of Matthew Orton.)

The university has held Undergraduate Research Day annually since 1998. Students work independently alongside faculty mentors in semester-long projects presented to the university community. Selected students later present their endeavors at the annual National Conferences on Undergraduate Research. Student Blake Hudson (seen here) explains his research. (Courtesy of Matthew Orton.)

In 2002, professor of art Scott Meyer (center) and his students constructed a 40-foot long anagama kiln, based on Japanese ceramics tradition and design. The art program fires the kiln, built into the hillside near the John W. Stewart Student Retreat, twice a year. The firing process requires about 100 hours and uses 12 to 14 cords of wood. (Courtesy of Matthew Orton.)

Six miles northeast of the university on Spring Creek Road resides Ebenezer Swamp Ecological Preserve. The swamp covers over 60 acres of wooded wetlands and is home to numerous species of fungi, plants, and animals. A 675-foot boardwalk allows visitors to tour the swamp without damaging the ecosystem. Pictured here are Montevallo students, from left to right, Cristi Vaughn, LaQuanda Frederick, and Kadrian Delaine, testing the water at Ebenezer Spring. (Courtesy of Matthew Orton.)

In 2004, the Alabama Senate passed a resolution commending students and faculty of the Michael E. Stephens College of Business. From left to right are Michael E. Stephens (Montevallo alumni and founder of the Lakeshore Foundation), William Rupp (former dean of the college), Rodger Mell Smitherman (Montevallo alumni, state senator, and Board of Trustees member) and Robert M. McChesney (thirteenth president of the University of Montevallo). (Courtesy of Matthew Orton.)

A current tradition on campus since 1998 is the "Life Raft Debate." An apocalypse has occurred, and a new civilization must be built, and the only survivors are students and professors on a life raft. Through debate, professors must prove their discipline's merit to student survivors in order to lead this new world. The losing professors go overboard. The 2005 winner was history professor Wilson Fallin. (Courtesy Matthew Orton.)

The 2007 men's soccer team finished with a school record 18 victories, 11 of those shutouts, and ended the season ranked fourth in Division II. The team qualified for the men's soccer tournament and advanced to the Final Four before losing in double overtime 1-0. Student athletes Jonathan Maloney (seen here) and Adam Frazer were named All-Americans at the end of the season. (Courtesy of Matthew Orton.)

The 2005–2006 men's basketball team was the first Montevallo sports team to be ranked at a No. 1 position at the Division II level. The team ended the season with a 29-5 record and advanced to the Elite Eight of the Division II NCAA tournament. From left to right are players Grant Urbanski and Greg Brown, and coach Danny Young. (Courtesy of Matthew Orton.)

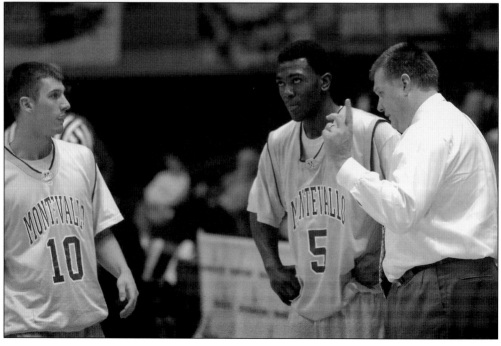

Building upon past tradition, the University of Montevallo's College of Education has had continued strong leadership and excellent instructors. Terry G. Roberson, Ed.D, pictured above, served as dean of the College of Education and dean of Graduate Studies before his appointment as provost and vice president for academic affairs in 2007. Seen at right is John F. (Jack) Riley, Ed.D., who served as dean of the College of Education and later as dean of graduate studies. (Courtesy of Matthew Orton.)

In 2007, Montevallo dedicated the Robert M. McChesney Student Activity Center. This photograph shows, from left to right, Robert M. McChesney, 13th president of the university; Frank "Butch" Ellis, alumni and board member; and Philip C. Williams, 14th president of the university. McChesney served as president from 1992 to 2006. Williams succeeded him, serving until 2010, and is now president of McNeese State University. (Courtesy of Matthew Orton.)

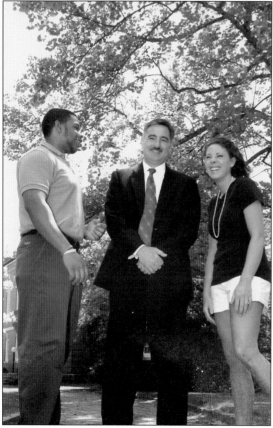

John W. Stewart III became the 15th president of the university in 2010. He earned his doctorate in English from the University of Southern Mississippi, focusing on African/Caribbean literature and also the Harlem Renaissance. Previous to Montevallo, Stewart was vice president for institutional advancement for Flagler College in St. Augustine, Florida. President Stewart is shown here with students Kouri Allen (left) and Jessica Robinson (right). (Courtesy of Matthew Orton.)

Seven

COLLEGE NIGHT

The most distinct and notable tradition of the school since 1919 has been College Night. While most colleges and universities focus their homecomings around athletic competition, the University of Montevallo instead divides students into two teams based on the school colors, the Golds and the Purples. These teams engage in spirited competition starting with intramural sports matches and culminating in a musical production, whose writing, directing, lighting, sets, choreography, costumes, and performances are all done by the students. Judges from state and regional fine arts institutions award points to various aspects of the shows and the results, along with those of the athletic competitions, are tallied. At the moment of the final announcement in Palmer Auditorium, a hush comes over the audience as they wait to hear if that year's work will result in either a "Purple Victory" or a "Gold Victory."

In 1953, college president John Caldwell reported to the Board of Trustees: "This is the antithesis of regimentation . . . it says, as do the students of Montevallo on College Night, by 'lending my best, creatively, to the work of the community, cooperatively, we all achieve the magnificent symphony of social living.'"

The Library of Congress has named the event a "Local Legacy" within the American Folklife Center.

The following images capture the spirit, creativity, and enthusiasm of these students as they engage in collaborative efforts to ensure their side's triumph. Long-lasting friendships result from these efforts and the institutional loyalties these students and alumni develop are a special part of the Montevallo experience.

Ammi Copeland was Assistant Gold Leader in 1932 and Assistant Purple Leader in 1933. In 1932, Alabama College's *Who's Who* voted Copeland as "Cleverest."

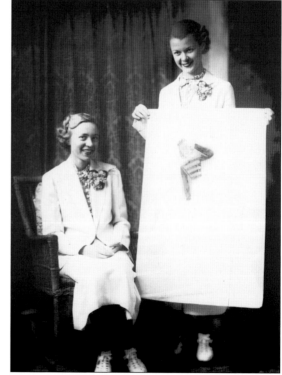

The 1937 winning Purple side, captained by Aeolian McRee and Emily McLendon, produced *The Story of Noam*. Aileen Holley and Martha Nicolson led the Golds, who put on the show *A Fantasy of the Gypsy Violin*. The dedicatee was Mattie Lee.

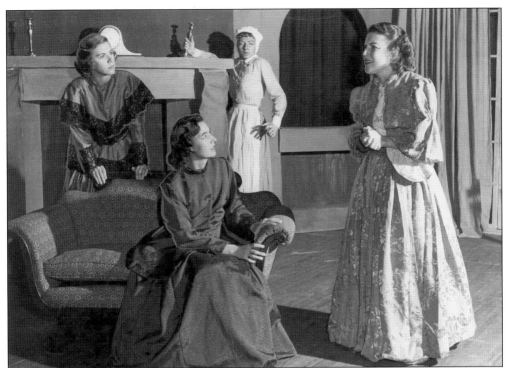

In 1949, the College Night Gold Team, led by Barbara Andrews and Dottie Breland, produced the drama *Evil as the Night*, seen above, and a stunt named *Button and Foes* or *My Love Struck a Red, Red Pose*. The winning Purples, led by Audrey Golightly and Twynette Beasley, produced the drama *Conflict* and a stunt called *A Light Comedy* or *The Blight of Night in Elferescent*. Dr. Hallie Farmer earned that year's dedication.

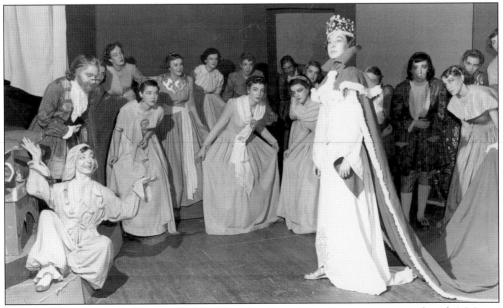

In 1951, the winning Gold Team, led by Cora Curtis and Dot Baumgartner, produced *A Matter for Consideration*. Mr. George Winslett was that year's dedicatee.

This photograph shows Betty Ann Overton, business manager; and Pat Hornung, chairman of typing for the 1952 Gold Team.

Joan Gregory and Mary Frances Estes led the 1952 winning Gold Team, which produced *Off the Hearthstone*. This drama, performed as a musical comedy, featured women fighting for the right to vote.

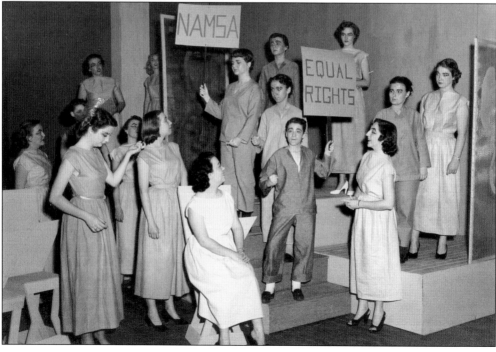

This 1952 photograph shows Assistant Director Sue Dobbins and Art Director Ethel Rattray for the Purple Team, which produced *Journey from a Star*. The event honored Pres. John T. Caldwell with the dedication.

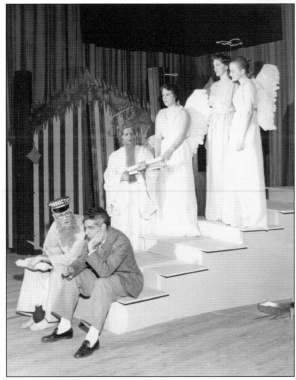

The 1959 winning Gold Team headed by Barbara Walker and Jean Findlay produced *The Right or Left of N.B. Tween*. Beloved and longtime professor and 1925 alumna Willilee Trumbauer was that year's dedicatee.

This 1964 photograph shows SGA president Jack Fleming announcing a Gold victory after their final production of *The Tree Makes Three*. The event honored Miriam Collins with the dedication.

In 1964, the Purple side cheerleaders were, from left to right, Kay Shirley, Joy Skelton, Janet Carriger, and Carol Huey.

In 1968, Pat O'Rourke, Purple leader, is shown here directing the Purple cast in *And It's All Tax Free*. Purple won this year. Mary Martin was that year's dedicatee.

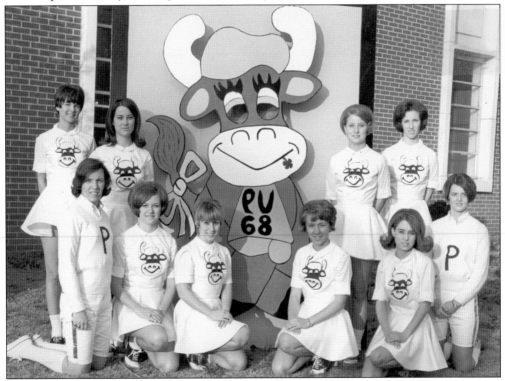

The Purple cheerleaders are shown here in 1968. The cheerleaders are, from left to right (first row) Gloria Birmingham, Myra Lawley, Diane Dawson, Lynn Colburn, Pat Stewart, and Cheryl Sanderson; (second row) Peenie Whitman, Lynn Evans, Claudia Dearman, and Janis Standridge.

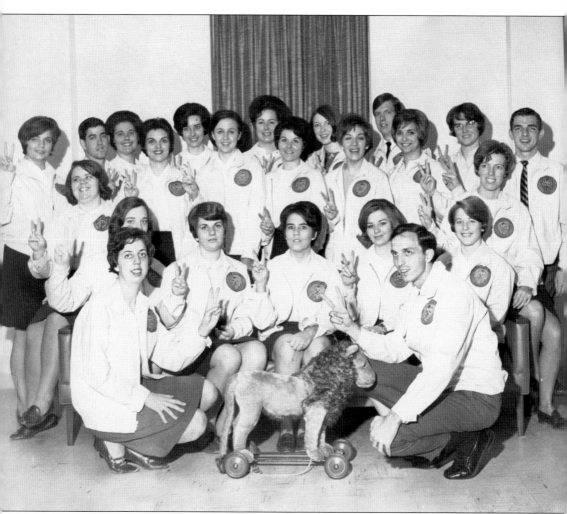

This image shows the 1967 Gold cabinet, which produced *Quench Finch (Lamore or Less)*. The members are, from left to right, (first row) Vickie Hymel and Doug Burnham; (second row) Donna Jones, Melanie Petithory, Lucille Langham, Janice Ware, Judy Gibbs, Barbara Johnson, and Sandra Boykin; (third row) Bunny Hardin, Fred Crawford, Pat Skelton, Freda Keller, Margaret Childers, Sharon Henderson, Peggy Gaskin, and Jimmy Hargrove; (fourth row) Felicia Pope, Sandra Massey, Judy McDonald, Ann Clapp, Ed Norment, and Suzanne Durham. Mary Frances Tipton earned that year's dedication.

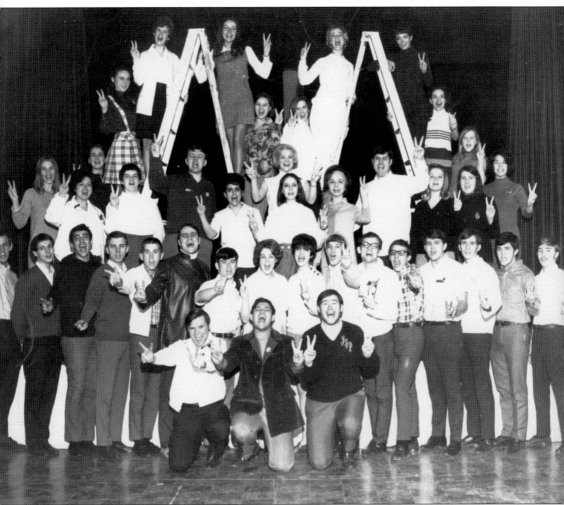

This 1969 photograph shows the winning Purple side, led by Donna Donnelly and Jim Weese. The cast members are, from left to right, (first row) Terry Horne, Daryl Schoeder, and Stan Powell; (second row) Tim Tidwell, Fred Norrell, Frank Cruz, Robert Altman, Ronnie Glover, Tommy Killian, Ronnie Cain, Trudy Davis, Sherry Stanley, Danny Deese, Gary Mitchell, Robert Hodges, Ron Lyerly, Johnny Parker, and Jack Spahr; (third row) Anne Ruff, Janice Frey, Marsha McCleod, Hal McIntosh, Fay King, Susan Patridge, Beverly Bonifay, Ann Hayes, Fred Holbein, Bonny Jones, Beth Perry, and Glenda Ogle; (fourth row) Judy Ling, Melody Nelms, Sharon Stallworth, Rene Van Tuyll, Peggy Williams, Linda Leo, and Cindy Taylor. Their production was entitled *A Rib and a Fig Leaf*. College Night dedicated the event to English professor Sarah Puryear.

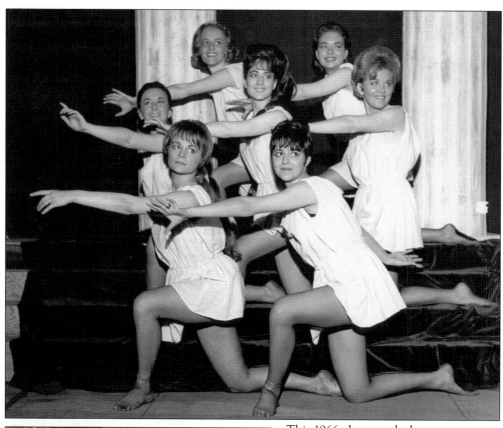

This 1966 photograph shows a scene from the Purple production *Populi Sunt Victimae*. Kerry Hancock and Ted Bridges led the Purple Team and Dr. Katherine Vickery, psychology professor, was dedicatee. The Golds won this year.

In 1973, the Purples, led by Glinda Ogle Godwin and Mike Murphy, produced the show *Ad Lib*. Pictured here are Judy Nordan Trotter and Walter Clopton. The event honored Jack Honeycutt and Don D. Hayes with the dedication.

Janet McLaughlin and Mike Bohorofoush were the Gold leaders in 1977. The Golds' winning effort was anchored by the production *In the Face of Dawn*. Jeanette Crew earned that year's dedication.

The 1977 Gold sign for their production, entitled *Victory Ariseth at Dawn*, is shown here outside of Farmer Hall. As part of College Night tradition, both Purple and Gold sides construct signs to highlight their respective shows, earning teams points in the overall competition.

In 1979, the Purples, led by Sharon Parks and Mike Dillard, produced *Until Tomorrow* with cast members, from left to right, Leann Stewart, Gary Mahon, and Lou Anne Wright. The Golds won this year. Inez Jones was that year's dedicatee.

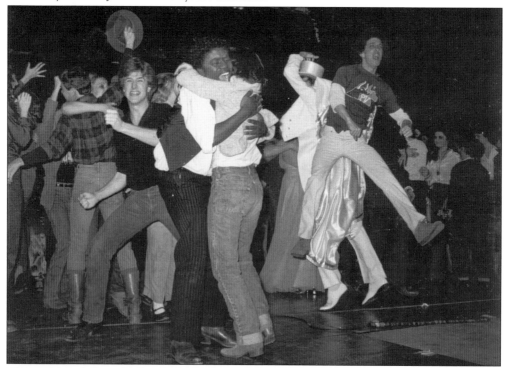

This 1980 image shows the Purples, led by Karen Kelly and Steven Hitt, reacting to the announcement of their victory. The Purple production was entitled *The Ballad of Saltpeter Flats,* and the event awarded the dedication to Mary Frances Tipton.

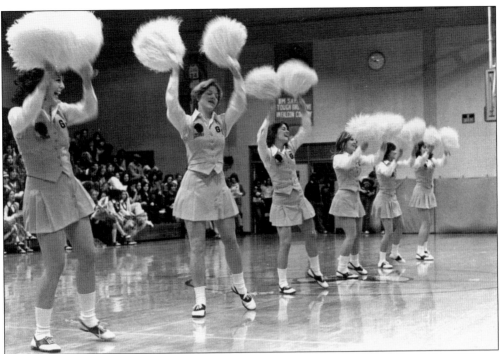

The 1980 Gold cheerleaders are shown here performing at Myrick Hall. Liz Farrell and Mike Williams led the Golds this year in their production of *To the Valley of Chase* or *Long Live Hobindale*.

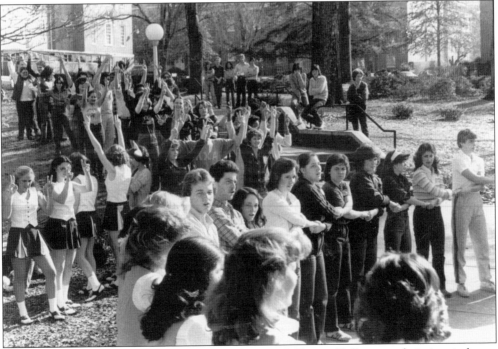

This 1981 image shows the Purple and Gold sides outside Farmer Hall raising their signs in hopes of victory. In this photograph, the Purples are in the background as the Golds in the foreground are singing their side's song.

This 1982 photograph shows the Purple side orchestra pit. A key component for all productions is original music composed and arranged by the students.

This 1985 image shows the Gold leaders Melanie Poole and Jerry Bullock and the Purple leaders Brett Dollar and Brooks Burdette. The Golds won this year; their production was *Truckstop 119*. The Purple production was *Where There's A Will*. College Night awarded that year's dedication to Linda Mahan.

MAKEUP WORKSHEET MAKEUP WORKSHEET

PRODUCTION: _____ ACTOR: Jill Swann PRODUCTION: _____ ACTOR: Barry Baros
CHARACTER: ANALYSIS: CHARACTER: ANALYSIS:
Little Miss Muffet OLD KING Cole

PROSTHESIS	Eye	Nose	Cheek	Mouth

Base	Highlights	Shadows
Eye liners	Powder	Hair
Note:		

PROSTHESIS	Eye	Nose	Cheek	Mouth

Base	Highlights	Shadows
Eye liners	Powder	Hair
Note:		

Each team for College Night creates a "production book" as part of the process, acting as an archive for each show. These books contain the program, scripts, set plans, choreography, musical scores, artistic design, props instruction, costume sketches, and names of those in the cast, cabinet, flunkies, business, and publicity. This image shows a makeup worksheet for the 1990 Gold show *No Rhyme . . . No Reason.*

The Golds in 1999, led by Maureen Mulroy and Greg Lee, produced *WGLD*. This image shows Joel Ramsay playing WGLD disk jockey "Reed Martin." David Pritchett earned that year's dedication. (Courtesy of Matthew Orton.)

In 2003, Kay Butts and Desmond Porbeni led the Purples in their production *Zeigfeld: A Love Story*. This scene shows the performance of *Getting Married Today* with Chris Sams (front left) and Lindsay Taylor (front right). (Courtesy of Matthew Orton.)

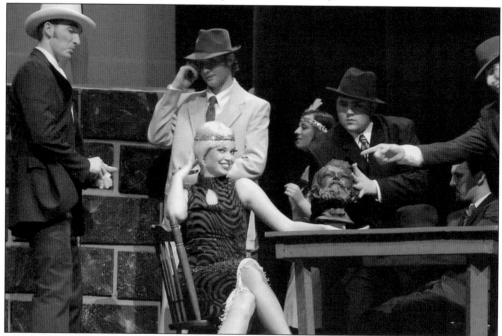

The 2003 Golds, led by April Green and Corey Stewart, put on the show *Toast of NYC*. This image shows, from left to right, James B. Hutchinson, Amanda Burdura, Trey Williams, Erica Work, Matt Mitchell, Billy Atchison, and Michael Hill. College Night dedicated that year's event to Cynthia Shackelford. (Courtesy of Matthew Orton.)

Eight

MONTEVALLO TODAY

By the early 1940s, the last of the local coalmines closed. However, since 1950, continued population growth of the region and close proximity to the Birmingham area allowed Montevallo to thrive and prosper, with the town growing to nearly 5,000. As the college, and then university, grew during the 1960s, the ties between campus and town increased.

Montevallo's Orr Park and Parnell Library offer recreation, arts, and cultural programs that bring richness and life to the town. Furthermore, Montevallo shares sister-city designation with Echizen, which is in Fukui Prefecture, Japan. Cultural exchanges take place yearly between the two. The recent addition of the American Village has brought thousands of schoolchildren and other visitors to the town. The newly constructed Alabama National Cemetery provides a place of rest and honor for those who served our nation.

This concluding chapter will allow one to take a virtual stroll through the town and witness some of the changes over the last 60 years.

The 1950 gubernatorial campaign witnessed two colorful characters coming to Montevallo. Gordon Persons, seen above, distinguished himself from the other 11 candidates by making campaign appearances with a helicopter. Speaking to his wife, he was quoted, "Honey, that's it. With 12 candidates in this race somebody with something out of the ordinary will attract attention and win." Robert Kirk "Buster" Bell, seen below, used a gasoline-powered "Victory Train" that carried the slogan "Build with Bell To-Day's Man for Alabama's To-Morrow." *Life* magazine profiled that year's race, won by Persons.

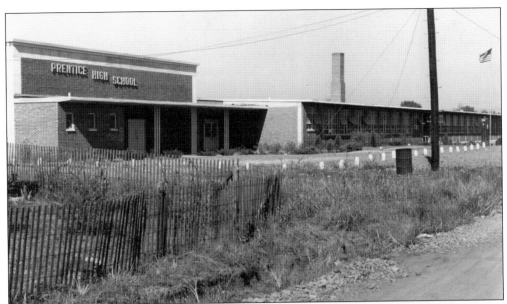

Constructed in 1950, Prentice High School served the African American population in the town of Montevallo. Before this, the town bused those students seeking a high school diploma to the county training school in Columbiana. The first graduating class, under principal Luther L. Penn, numbered 62. The last class graduated from Prentice in 1970 and the structure was repurposed into Montevallo Middle School. The building was named after Rev. Joseph Prentice. (Courtesy of Shelby County Historical Society.)

Walter Patrick McConaughy (1908–2000) was born in Montevallo and educated at Birmingham-Southern College. In 1930, he joined the US State Department, where he served until 1974. His ambassadorial posts included Burma, South Korea, Pakistan, and Taiwan. In the 1960s, he rose to U.S. assistant secretary of state for Eastern affairs.

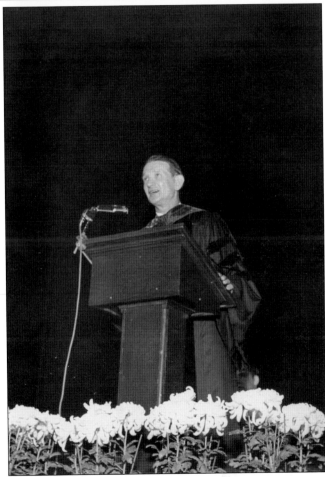

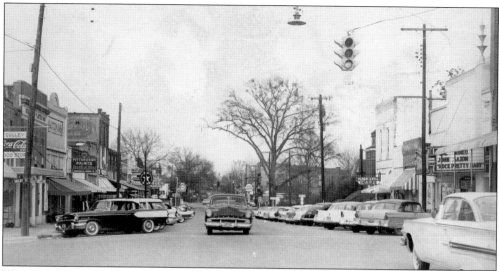

This 1956 image, taken from the intersection of Main and Shelby Streets, shows a bustling downtown Montevallo. Major storefronts on the left include McCulley's Food Store, Merchant and Planter's Bank, Klotzman's Dry Goods, and Montevallo Lumber Company. On the right sit the Strand Theatre and the Plaza Grill Café.

This c. 1956 photograph shows Montevallo High School's homecoming parade on Main Street. In the back left, the flatbed truck carries the homecoming queen. Montevallo First Baptist Church, Plaza Grill Café, and Lucille's Barber Shop are visible on the right.

Ralph Sears joined the Alabama College staff in 1948 as radio director, supervising broadcasts of WAPI, the campus radio station. Later, he became director of public relations. In 1972, he began his service as mayor of Montevallo until his retirement in 1996. From 1967 to 1984, he and his wife Marcia Sears owned the *Shelby County Reporter*. Montevallo named the local stretch of Highway 119 in his honor.

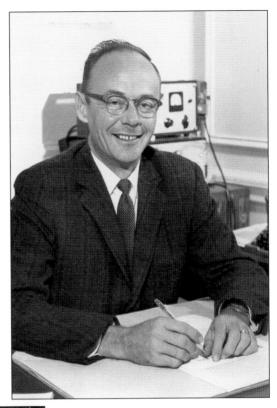

Montevallo named Orr Park for Dr. Milton L. Orr Jr., a prominent dentist, councilman, and mayor from 1966 to 1972. Before the park was built, the area was undeveloped. In addition to playgrounds, picnic tables, and paved walking trails, the park is a showplace for local artist Tim Tingle's work. Tingle transforms trees into works of art by carving them into figures such as dragons, human faces, and animals. (Courtesy of Clark Hultquist.)

An early 1980s photograph shows the crowd at a Montevallo High School football game. In 2006, the high school named the site Richard Gilliam Field at Theron Fisher Stadium. Richard Gilliam led the successful integration of the Bulldogs football team in 1973. He also coached basketball and baseball.

This 1980 photograph shows a Pea Ridge Fire Department truck participating in Montevallo's annual Fire Prevention Parade. First held in 1975, the event runs every October to kick off Fire Prevention Week. The parade consists of fire trucks representing communities from the surrounding area.

Eclipse Coffee and Books, founded in 2001, soon became a Montevallo favorite for the university community and local citizens. It operates as a bookstore, restaurant, and cultural center offering poetry readings, local musicians, and monthly trivia competitions. (Courtesy of Clark Hultquist.)

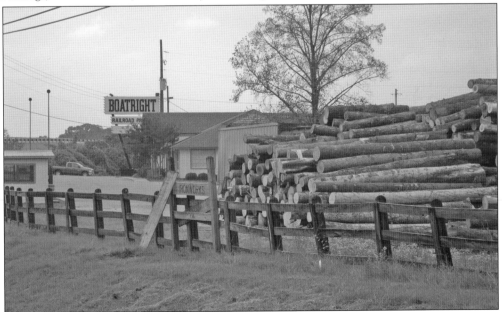

James M. Seaman founded Seaman Timber in 1955. Located at the intersections of Highways 25 and 139, the firm has been a producer of railroad crossties. Spanning 75 acres, the grounds include a lumber treatment complex, a railroad bridge and switch tie department, and a trim and stacking facility. Recently acquired by Boatright Enterprises, the company employs 100 workers and has estimated revenues of $50 million. (Courtesy of Clark Hultquist.)

A Montevallo business stalwart, Merchants and Planters Bank, founded in 1902, long sat at 609 Main Street. In 1965, the firm relocated to 835 Main Street at the previous site of the St. George's Hotel. Peoples Bank and Trust Company purchased the bank in 1998 and operated at that location until 2007 when BankTrust, of Mobile, Alabama, merged with Peoples Bank and Trust Company. (Courtesy of Clark Hultquist.)

Regions Bank, located at the intersection of North Boundary and Main Streets, is built on the foundation of what was once a Standard Oil service station. At this site in 1980, Shelby State Bank opened its first office in Montevallo. First Alabama Bank acquired Shelby State Bank in the mid-1980s, and in 1994, First Alabama Bank changed its name to Regions Bank to reflect its growing presence throughout the South. (Courtesy of Clark Hultquist.)

The Alabama National Cemetery, operated by the US Department of Veterans Affairs, is located on Highway 119. The 479-acre facility, opened in April of 2009, is currently under development; the first phase will eventually provide 7,395 casket gravesites, 999 cremation sites, and approximately 2,700 columbarium niches. This photograph shows the dedication of the site with Rev. Dr. James F. Tuohy and Rev. Bill King.

The American Village is a nationally recognized educational institution. Its mission is to strengthen and renew the foundations of American liberty and self-government through engaging and inspiring citizens and leaders. It has pioneered experience-based academic programs in American history, civics, and government that draw tens of thousands of students and general visitors from throughout Alabama and the nation. Designated as a Veterans Living Legacy, it teaches the ideals of liberty. (Courtesy of the American Village.)

The Montevallo Arts Festival, held annually in April at Orr Park, first occurred in 2007. The festival is a weeklong celebration of the arts with concerts, theater performances, readings by noted authors, and art gallery exhibits. The art show features over 60 regional artists; the 2010 show attracted over 1,600 visitors. RaeJean Flatt, a local spinner and potter, is shown here creating yarn from wool at the 2008 festival. (Courtesy of Libbie Rodgers.)

The Montevallo Public Library first opened in 1958 and resided in several locations including city hall and the Depot in the Park. In 1984, the Parnell family donated the renovated telephone company switching building to house the library. Having outgrown this space, the Parnell Memorial Library opened in its new location, in 2007, adjacent to Orr Park. The new structure also houses a theatre and art gallery. (Courtesy of Clark Hultquist.)

BIBLIOGRAPHY

Alabama Society, Daughters of the American Revolution. *Some Early Alabama Churches.* Birmingham, AL: Parchment Press, 1973.

Emfinger, Henry A. *From Wilson's Hill To Montevallo, Alabama: A Mound in A Valley.* Aldrich, AL: self-published, 2006.

Griffith, Lucille. *Alabama College, 1896–1969.* Montevallo, AL: University of Montevallo, 1969.

————. *White Columns & Red Brick: The University of Montevallo Buildings.* Montevallo, AL: University of Montevallo Press, 1988.

Meroney, Eloise. *Montevallo, the first one hundred years.* Montevallo, AL: Times Printing Company, 1977.

Nutting, Alissa. "Montevallo: A Mound in a Valley." *Alabama Heritage* 84 (Spring 2007): 18-29.

Shelby County Heritage Book Committee. *The Heritage of Shelby County, Alabama.* Clanton, AL: Heritage Publishing Consultants, Incorporated, 1999.

Shelby County Reporter. Shelby County Historic Images—The Early Years. Vancouver, WA: Pediment Publishing, 2005.

Tipton, Mary Frances. *Years Rich and Fruitful: University of Montevallo 1896–1996.* Montevallo, AL: University of Montevallo, 1996.

University of Montevallo Archives and Special Collections, Carmichael Library, Montevallo, AL.

www.cityofmontevallo.com

www.montevallo.edu

www.rootsweb.ancestry.com/~alshelby/schs.html

www.arcadiapublishing.com

Discover books about the town where you grew up, the cities where your friends and families live, the town where your parents met, or even that retirement spot you've been dreaming about. Our Web site provides history lovers with exclusive deals, advanced notification about new titles, e-mail alerts of author events, and much more.

Arcadia Publishing, the leading local history publisher in the United States, is committed to making history accessible and meaningful through publishing books that celebrate and preserve the heritage of America's people and places. Consistent with our mission to preserve history on a local level, this book was printed in South Carolina on American-made paper and manufactured entirely in the United States.

This book carries the accredited Forest Stewardship Council (FSC) label and is printed on 100 percent FSC-certified paper. Products carrying the FSC label are independently certified to assure consumers that they come from forests that are managed to meet the social, economic, and ecological needs of present and future generations.

FSC
Mixed Sources
Product group from well-managed forests and other controlled sources

Cert no. SW-COC-001530
www.fsc.org
© 1996 Forest Stewardship Council

Find Your Place in History.